CHANGING PERCEPTIONS
MILESTONES IN TWENTIETH-CENTURY BRITISH PORTRAITURE

The artist must see all things as if he were seeing them for the first time.

Henri Matisse

CHANGING PERCEPTIONS

MILESTONES IN TWENTIETH-CENTURY BRITISH PORTRAITURE

ELIZABETH CAYZER

THE
Alpha PRESS

BRIGHTON • PORTLAND

Copyright © Elizabeth Cayzer 1999

The right of Elizabeth Cayzer to be identified as author
of this work has been asserted in accordance with the Copyright, Designs
and Patents Act 1988.

2 4 6 8 10 9 7 5 3

First published 1999 in Great Britain by
THE ALPHA PRESS
Box 2950
Brighton BN2 5SP

and in the United States of America by
THE ALPHA PRESS
5804 N.E. Hassalo St.
Portland, Oregon 97213-3644

British Library Cataloguing in Publication Data
A CIP catalogue record for this book is available from the British Library.

Library of Congress Cataloging-in-Publication Data
Cayzer, Elizabeth.
Changing perceptions: milestones in twentieth-century British
portraiture/Elizabeth Cayzer.
p. cm.
Includes bibliographical references and index.
ISBN 1–898595–29–1 (hc: acid-free paper). — ISBN 1–898595–30–5
(pbk.: acid-free paper)
1. Portrait painting, British. 2. Portrait painting—20th
century—Great Britain. I. Title.
ND1314.6.C39 1998
757'.0941'0904—dc21 98–39847
CIP

Designed by Ian Wileman

Printed by Butler and Tanner,
Frome, Somerset

This book is printed on acid-free paper

Contents

CHANGING PERCEPTIONS

Preface

Imagine two portraits hung side by side, one a John Singer Sargent, the other a Francis Bacon. It is almost impossible to accept that the recognisable, ebullient 'Sargent' and the blitzed features of the 'Bacon' have anything in common, yet each is a painting of a human being. What has happened . . . ?

The stirrings of the human heart are most perfectly represented through the intuitive perceptions of writers, musicians and artists. Looking at the portraits painted in Britain since 1900 one can see, in the best of them, a fascinating series of responses to the changing world. It is these visual responses that are the key to a better understanding of the silent revolution which has so altered both our age-old patterns of existence and the way in which we apprehend things around us.

Most of the artists I have chosen to discuss in this book are 'occasional' portraitists – those who have not had to rely on finding clients in order to make a living – artists who have looked with a fresh eye at their sitters when the challenge has arisen. However, I could not ignore some of the best-known Edwardian portrait painters such as Sargent, Lavery and Orpen who, although imprisoned somewhat by their calling and inevitably running out of imagination at times, also reflect the mutterings and murmurings of the collective British consciousness.

Anyone visiting The National Portrait Gallery in London will be struck by its busyness: the public enjoy looking at portraits. But this involves effort. Portraits, like all good paintings, will not reveal their secrets without a two-way dialogue with the spectator. Such a dialogue is profoundly different from the quick 'snap-shot' effects produced by photography or by television's daily diet: each so disposable. Yet it could also be argued that these modern media have replaced the need for portraiture: we know what people look like – but do we? It is a question of *how* the artist scrutinises his sitter – followed by our contemplation of the resulting picture – that makes the difference. It is this that still allows portraits to be objects of value while some of them are very great statements of truth also.

The events of the last hundred years seem to have altered forever people's consciousnesses and thus their expectations of what life holds for all of us. As this has occurred people's physical beings have changed too: they have been released from one historical situation and faced with the next one and correspondingly their dress, stance and gestures have moulded themselves to altering circumstances. This is exemplified by looking at the two portraits by Sargent and Bacon reproduced on the cover of this book – one man painting at the beginning of the century, the other nearing its end. These, and the other portraits discussed in Milestones, detail the significant changes that have taken place in twentieth-century portraiture, while the background against which the painters worked, together with their manner of coping, are explored in Changing Perceptions.

MILESTONES

John Singer Sargent (1856–1925)

Dame Ethel Smyth, 1901

BLACK CHALK ON PAPER
59.8 × 46 cm (23 × 18¹/₂ ins)
NATIONAL PORTRAIT GALLERY, LONDON

Sargent, when he was not engaged in painting, found music to be his most consuming interest and favourite form of relaxation. He numbered many musicians among his circle including Dame Ethel Smyth (1858–1944) the sister of his close friend Mrs Charles Hunter, to whom this drawing is dedicated. Flouting the conventions of the times, Ethel Smyth had entered the Leipzig Conservatory in 1877 and soon her work as a composer was acknowledged by the leading musicians of the day. In 1893 her Mass in D was performed at the Albert Hall, and in 1906 her opera, *The Wreckers* – considered her major achievement – was staged in Leipzig and Prague, and later in London. Thereafter she espoused the cause of women's suffrage and her strident approach to it came to irritate Sargent.

This drawing was made while she was sitting at the piano singing and, according to the portraitist Charles Furse, is "one of the most remarkable *singing* portraits extant," though the sitter's nephew commented, "Fancy his having done Aunt Ethel biking and catching flies!" (Lomax and Ormond, p. 75). The reason for including it in this book, in place of a portrait in oils, is that it is in such a piece, where he is doing what he wants to, that one can see most clearly how Sargent is looking at an alert intelligence in the early years of the new century. Unlike many of his portrait drawings of the era this one does not set out to flatter. There is no indication that Ethel Smyth is interested in her appearance. Her hair is piled severely under her hat and the cut of her jacket is mannish and unadorned. She is the 'new woman', capable, determined, and assertive. But like his great predecessor Ingres, who also made portrait drawings, Sargent manages to suggest light, colour and texture, despite the medium. The face emerges from out of the dark, smudgy, background which has isolated it and given it added definition; this is characteristic of his work of this nature.

Throughout his career Sargent painted informal oil sketches of his friends and fellow artists. This was a peculiarly French practice which, for him, led on to the later portrait drawings. From 1900 these drawings came gradually to replace his large set-pieces and thus freed more of his time for travel and landscape painting.

JOHN SINGER SARGENT, born in Florence, educated in Europe, trained as an artist in Paris, and a long-time resident in England, always remained an American citizen. His cosmopolitan inheritance enabled him, as a portrait painter, to pinpoint his sitter's nationality and background so that they would immediately be recognisable. It is natural therefore that the British should consider him as one of their own. More than any other artist in Britain he has come to epitomise the Edwardian era, a time when big business was seeking social ambitions, when the Jewish community was being recognised, and

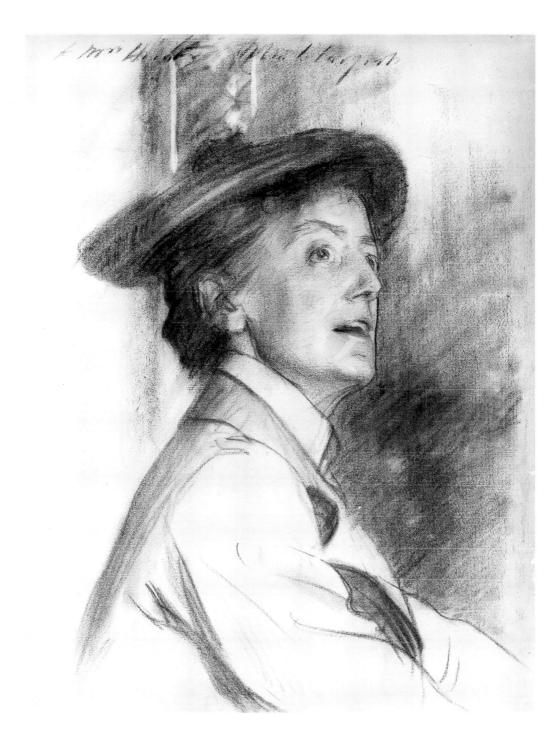

JOHN SINGER SARGENT

Dame Ethel Smyth, 1901

when the aristocracy were having their final fling. Sargent was propelled into this world in the mid-1880s after a meritorious career in Paris had been somewhat blunted by the outraged reception at the Salon of his portrait of *Madame Gautreau*. This lady tended to attract gossip: when he pictured her in a décolleté dress it was too much.

As a personality Sargent was shy and modest, happiest either in musical circles, where he could hide behind a performance and show his innate congeniality, or amongst his family. He was a close friend of Henry James – indeed he possessed all the qualifications to make him a Jamesian character: he was an expatriate, more cultured than many Europeans, and an enigma. In his work he was daring, dashing, and a brilliant technician – a compulsive painter who scorned the use of studio assistants. His portrait compositions were outstanding, reminiscent in their imaginative use of space of Degas. But once he was approved of and espoused by the British aristocracy this characteristic became less pronounced. His pictures were often required as pendants to an ancestral portrait by Gainsborough or Reynolds and this, coupled with an incessant demand for his services, meant a diminution in his originality. Writing with emotion from Palermo in 1901 he made his feelings clear: "I have come to this tuberculous place to avoid portraits. The plague in Naples answers very well too" (Olson, p. 225). At the end of the decade he had virtually eschewed portraiture though, in 1913, he willingly agreed to paint Henry James to commemorate the writer's seventieth birthday. The portrait was the idea of both James's American and English friends and he was charmed by the sittings, Sargent "being so genial and delightful a *nature de grand maître* to have to do with", and thrilled with the result (Montgomery Hyde, p. 244). But charcoal drawings had become Sargent's preferred medium for portraiture by now for they were done in two hours at a charge of 21 guineas each though so popular did these head and shoulder sketches become that, once more, he was inundated with sitters. By 1920 he was charging 100 guineas a head and becoming heartily sick of the work.

Accusations have been levelled at Sargent's degree of psychological insight and it is clear that this is of variable quality. He seemed attracted by mental energy which enabled him to make most interesting and engaging portraits of some of his plainer female sitters. Yet, so stereotyped has his image become that it is sometimes easy to overlook this aspect of his work. However, throughout his career, there is clear evidence of an edginess, and an irritation with the tradition of painting 'personality' portraits of people at home in their environment. Indeed his enduring interest in the individual points the way forward to the changes that were to occur in portraiture over the twentieth century.

BIBLIOGRAPHY

FAIRBROTHER, Trevor J. *Sargent Portrait Drawings* (Constable, 1983)

LOMAX, James and ORMOND, Richard *John Singer Sargent and the Edwardian Age* (Leeds Art Galleries/National Portrait Gallery, 1979)

MONTGOMERY HYDE, H. *Henry James at Home* (Methuen, 1969)

OLSON, Stanley *John Singer Sargent, His Portrait* (Macmillan, 1986)

ORMOND, Richard *J. S. Sargent Paintings, Drawings, Watercolours* (London, 1970)

Gwen John (1876–1939)

Dorelia by Lamplight, Toulouse, 1903–4

OIL ON CANVAS
54.6 × 31.7 cm (21¹/₂ × 12¹/₂ ins)
MR AND MRS PAUL MELLON

A FEW YEARS later, but worlds away from Sargent's social milieu, two young women, Dorothy (Dorelia) McNeill (1881–1969) and Gwen John, set out to walk from London to Rome. They were pursued on their journey not only by French peasants and potential lovers, but by letters from their friends curious to know of their progress. By now, one of Dorelia's most intimate 'friends' was Gwen's brother Augustus who, in November – knowing that after a change in intention they were heading for Toulouse – wrote: "I hope Gwen will do a good picture of you and that . . . it will be as wild as your travels" (Chitty, p. 58).

Their 150-mile walk from the ship at Bourdeaux was packed with events and adventures. They earned their keep by singing to and drawing the local people at each overnight stop – sometimes a risky occupation – and when their luck ran out they existed on the under-ripe grapes from the Entre Deux Mers vineyards. By all accounts Gwen John behaved in a bossy manner, expecting Dorelia to carry all her equipment: artists must preserve their strength for their work was her attitude. In essence Dorelia's was a peaceful character and she acted as an antidote to Gwen's shy but suddenly passionate nature, as she would do for Augustus over the next sixty years.

During their winter sojourn in Toulouse Gwen completed three portraits of Dorelia but none of them was "wild". In fact the portraits of Dorelia painted by Gwen and Augustus John in the first decade of the century say as much about their own personalities as they do about their sitters'. In his early portrayals Augustus casts her in the role of mysterious woman, earth mother, siren – for it was endemic to his character to be at one remove from reality; reality lacked the ease and charm he so needed in life. In contrast, Alfred H. Barr has described Gwen's early works as possessing "a penetrating, disquieting psychological flavour, . . . though always in perfect 'good taste'" (Langdale, p. 80) while Germaine Greer has spoken of Gwen's figures exhibiting "a sharp point of concentrated feeling" (Chitty, p. 16).

Here we have a poignant picture of Dorelia on the brink of life just before her brief affair with the mysterious Leonard 'B' and her later life-long involvement with Augustus – young, quiet, innocent, and seemingly unflurried by the effects of Gwen's bossiness.[*] All the artist's portraits contain the sort of stillness seen in *Dorelia by Lamplight* and in this case it does exhibit part of the girl's character, though in other instances Gwen achieves a stillness charged with a fierce, deep-seated emotion so typical of her own approach to life.[**] Her debt to Whistler, with whom she studied briefly, is evident in the use of closely related tones. The paint has been carefully laid on in layers of semi-translucent

[*] See Michael Holroyd, 'The Artist, His Mistress, Her Lover', *The Independent on Sunday*, 18 August 1996.
[**] See *Self Portrait*, 1899 in the National Portrait Gallery, London and *Girl with Bare Shoulders* (Fenella Lovell), 1909–10.

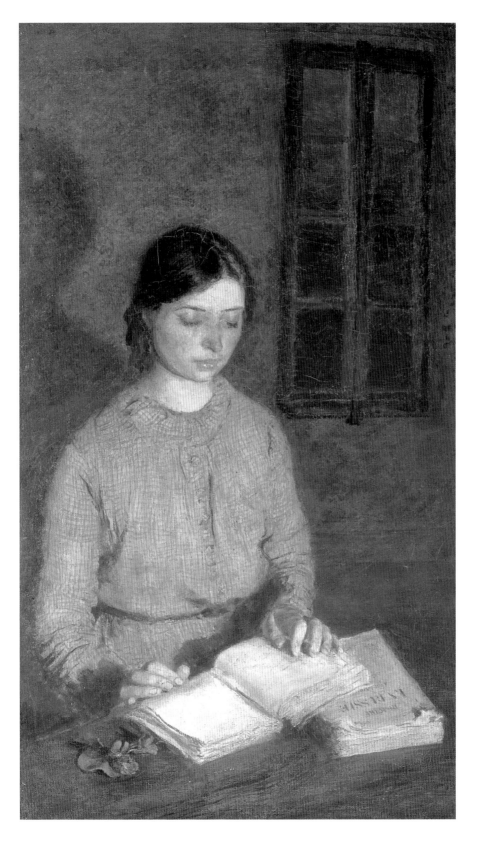

GWEN JOHN

Dorelia by Lamplight, Toulouse, 1903–4

glazes, which allow for tiny changes during the course of the work. Already, though, Gwen's interest in more abstract shapes, rather than just character, is apparent in the large shadow behind the girl's head and in the geometrical balance between the books and the window panes.

GWEN JOHN was one of a group of brilliant students attending the Slade School of Art in the 1890s. Thereafter, armed with a marmalade cake, she joined some friends – including her brother's future wife Ida Nettleship – in Paris where she attended Whistler's classes in painting at the Académie Carmen. Upon her return to London, Gwen described the years 1899–1903 as her "subterranean period" (Chitty, p. 49). During this time she inhabited a series of unsalubrious flats and had an unhappy love affair with the artist Ambrose McEvoy.

The pattern of her future existence was beginning to emerge – an alternation between passionate involvement with people and situations, and necessary isolation in order to recover, and to paint. When Dorelia McNeill ran off with Leonard 'B' in 1904 Gwen acted as Augustus and Ida John's emissary to exact her return; she was doggedly determined to win the argument. This apparently shy and timid woman could see nothing but logic in the strange *ménage à trois* that ensued. Equally, during her subsequent affair with Auguste Rodin her obsessive belief that she was the only woman for the sixty-three year old sculptor led her into extraordinary actions at the height of her passion. She was never one to pull her punches, writing to him of a rival: "cette femme qui vous a fait oublier tout. Et elle est méchante et sans intelligence" (Langdale, p. 33).

In 1904 Gwen John had settled permanently in Paris and for a long time she earned her living as an artist's model. She painted slowly and seldom had works ready for exhibition. During their affair Rodin encouraged her to draw but because she was frequently dispirited only a few oils were completed. Even the financial inducements of her brother's American patron John Quinn did little to encourage her to work faster. Quinn had quickly warmed towards Gwen's modesty and dedication though it was to be a decade before they did more than exchange letters. During that time his collection of art, and knowledge about it – initially guided by Augustus John – grew. He became involved also in the arrangements for the important Armory Show held in New York in 1913 which would launch the United States into the mainstream of world art. But Quinn's willingness and ability to help Gwen with her career during these years largely past her by, such was her unworldliness.

At the time of her introduction to John Quinn, a change in Gwen's style was occurring: no longer was she applying paint with meticulous brush strokes, instead it was being applied thickly in a single rather chalky layer. Her interest in conventional portraiture decreased too, to be replaced by a concentration on the figure as a series of shapes executed in much more closely related tones than hitherto. Her subject matter now included the nuns of Meudon near Paris – where she had taken rooms and become a Roman Catholic convert – and their charges from the nearby orphanage. Cats always featured in her work: they were her friends and handy models.

By the 1920s she came increasingly to work in gouache rather than oils and after the mid-1930s she ceased painting altogether. Her only one-woman exhibition was held at the Chenil Galleries in London in 1926. Prices were high, for already the Tate Gallery had acquired a number of her early paintings, and her reputation was growing.

Gwen John's sitters frequently express, in her interpretation of them, her own emotional 'cost of living' through a sense of isolation and shadowy melancholy, thus pointing towards the direction in which portrait painters in the twentieth century were going. Optimism and an assured sense of one's own place in the world – the artist's as much as the sitter's – are missing.

BIBLIOGRAPHY

BARBICAN ART GALLERY *Gwen John: an Interior Life* (1985)
CHITTY, Susan *Gwen John 1876–1939* (Hodder and Stoughton, 1981)
HOLROYD, Michael *Augustus John* (Penguin, 1976)
LANGDALE, Cecily *Gwen John: Catalogue Raisonné of the Paintings and a Selection of the Drawings* (Yale University Press 1987)
REID, B. L. *The Man from New York: John Quinn and his Friends* (Oxford University Press, 1968)

Mark Gertler (1891–1939)

The Artist's Mother (Golda Gertler), 1911

OIL ON CANVAS
66 × 55.9 cm (26 × 22 ins)
TATE GALLERY, LONDON

Remote both from the fashionable John Singer Sargent and the wayward and bohemian Gwen John the Gertler family had, in 1896, settled permanently in Whitechapel – an area of London close to the City, but a focus of Jewish refugees from the Russian pogroms. Whitechapel had some of the worst slums in the country and was ridiculously overcrowded so that the Gertlers lived for some time in a single room – five children and two adults. Jews were still regarded then by the indigenous population with dislike, and much resentment was felt against the Yiddish speakers for turning Whitechapel into a foreign enclave. Mark Gertler's parents would never become fully assimilated into the British way of life – indeed Golda Gertler never spoke other than Yiddish. Despite this she was a capable woman who had cared for her children alone in Galicia while her husband searched for work in America and Britain. And later, in Whitechapel, it was she who spotted one of his workers stealing fur. Mark was her favourite son and as he later said, "Her entire happiness is bound up in my progress" (Ben Uri, p. 1). Moving between her kitchen and her front doorstep, where she would sit observing the scene, she was always her son's confidant and willing model.

Mark and his mother are strikingly similar in looks – the same nose and mouth and a gaze that draws pertinent conclusions about the world they inhabit. In this portrait Golda is dressed smartly and seen, in some respects, as a conventional matriarch rather than depicted at work in her kitchen. Yet in no sense can this be called a totally typical British portrait of the Edwardian period. Golda was not British and here her antecedents are wholly apparent. The picture has an exotic feel to it and the colourful trimmings to her dress – its many elaborate tucks and folds – and her jewellery are all indicators of her Jewishness. But it is the face and hands, those badges of character, that make this an outstanding picture. This woman, who strayed not more than a mile from her Whitechapel home, has an inherent shrewdness and refinement – characteristics which were to be so magnificently realised again in her son.

By 1911 Mark had spent nearly three years at the Slade School of Art and his understanding of both the human form and of oil paint was fully developed. His artistic progress was rapid and he moved swiftly from one idea to the next. Soon the style in which this work is painted was superseded by less anatomically detailed figure work but never did he better the rapport, the speaking likeness, which makes this such a telling representation of his mother's personality.

The years 1910–12 were packed with new people and new experiences for Mark – and more was to come. In 1910 he had won first prize at the Slade for portraiture. The following February his work was singled out by Vanessa Bell as "remarkable really only considering his age (which was nineteen) . . . I think he may be going to be good!"

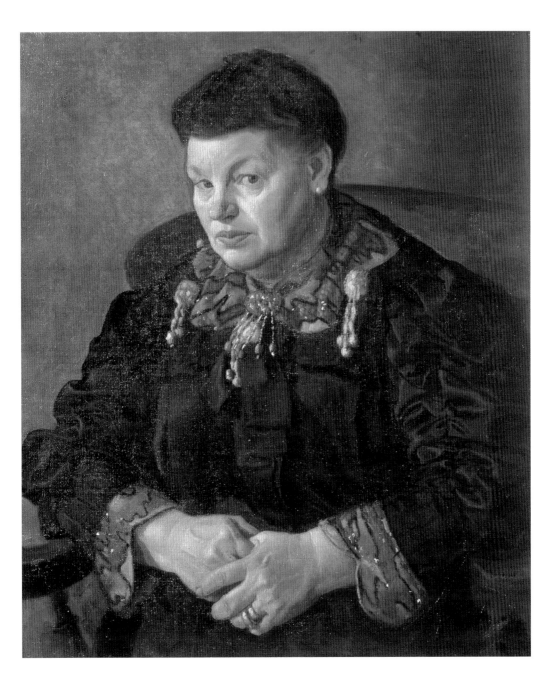

MARK GERTLER

The Artist's Mother, 1911

(Woodeson, p. 68). In November *The Artist's Mother* was exhibited at the New English Art Club in company with work by Sargent, Sickert, his teachers Tonks, Brown and Steer, and Augustus John. The picture was bought by Sir Michael Sadler, a noted collector and, delighted, Mark wrote to say: "What also pleases me is that it will actually 'rub shoulders' with those wonderful pictures I saw at your house. It is so nice to be encouraged. One works in such better spirits" (Woodeson, p. 76).

MARK GERTLER's early life contained few social advantages yet by the age of nineteen he had received recognition as an outstanding new talent. When he left school in 1906 he decided to become a painter after having read a biography of the Victorian artist W. P. Frith. He attended classes at the Regent Street Polytechnic for two years, often studying there in the evenings after a ten-hour day as an apprentice to a nearby firm of glass painters. Then his work was brought to the attention of the Jewish artist William Rothenstein who helped him to win a place at the Slade School of Art. His career there was remarkable and his contemporary C. R. W. Nevinson described him as "the genius of the place and besides that the most serious single-minded artist I have ever come across. His combination of high spirits, shrewd Jewish sense and brilliant conversation are unmatched anywhere" (Woodeson, p. 64). Portraiture dominated Gertler's work in the early years and the Jewish community in Whitechapel provided many models and introduced new subject matter to the gallery-visiting public. His outstanding critical reception in 1911, while still a student, brought him both patrons and commissions, as well as new friends in high places. Nevinson recalled the effect of his engaging personality upon Sir George Darwin whose portrait he painted in Cambridge: "At dinner he was offered asparagus for the first time. Being accustomed to spring onions, he started at the white end first, and the beautifully mannered don followed suit in order not to embarrass him" (Woodeson, p. 79).

Gertler's inquiring mind and total dedication to his profession meant that he was never satisfied with his work. Aware, and yet critical of the multiplicity of new ideas on art before the First World War, he tended then, and later, to steer his own course. Portrait commissions soon drained him creatively; as he once said: "there is something about the conditions which paralyses my work and I can produce nothing I like that is any use that way" (Woodeson, p. 179). His most innovative paintings were completed in the years up to 1920 and much of his lively personality, curiosity and intellectual challenging of life comes through in them. Thereafter he painted a large series of nudes that oscillate in style between an almost Eastern voluptuousness and a Renoiresque sentimentality. During the 1930s he produced a number of intricately patterned still lifes as well as figure pieces and some landscapes. He never was overly swayed by fashion and he always retained a coterie of faithful patrons. Critics, as is their want, wavered in their appreciation.

If, in terms of traditional portraiture, Gertler is an outsider, his racial inheritance of isolation and persecution – and consequently his intense awareness of his Jewish identity – put him at the centre of the new direction portraiture was now taking. This was towards an examination of an individual's place in the world, the significance of that individual, and what being an individual, and alive, could mean to the sitter. All of this was beginning to preoccupy artists when painting a portrait and, though emerging from a totally different position to Sargent or Gwen John, Gertler's preoccupations and theirs seem to converge.

His thinking in historical-political terms was deeply engrained with memories of mass pogroms and, together with other survivors and descendants of similar atrocities living in Britain, he helped perpetuate the effects of these experiences allowing them, by a process of osmosis, to be lodged in the artistic, as well as in the collective, consciousness. This vision of life was to be re-enforced for succeeding generations of artists – including Bacon, Auerbach and, in a sense, Freud – by images of trench warfare and the Holocaust.

BIBLIOGRAPHY

BEN URI ART GALLERY, LONDON *Mark Gertler – the Early and Late Years* (March–May, 1982)
CARRINGTON, Noel (ed.) *Mark Gertler: Selected Letters* (Rupert Hart-Davis, 1965)
WOODESON, John *Mark Gertler, Biography of a Painter, 1891–1939* (Sidgwick & Jackson, 1972)

Henry Lamb (1883–1960)

Portrait of Lytton Strachey, 1914

OIL ON CANVAS
244.5 × 178.4 cm (96¼ × 70¼ ins)
TATE GALLERY, LONDON

While the anguished and passionate Gertler was struggling to find his true artist's voice, Henry Lamb, suave, intelligent and well-established socially, was painting his friend Lytton Strachey (1880–1932) – the literary critic and biographer. The portrait is astonishing. On first sight it could be described as a caricature, but contemporaries have attested to its speaking likeness. That Strachey lived in a rarified world of his own behind round spectacles was often noted, while descriptions of his gawky body, immensely long legs, and refined fingers abound. The picture won immediate recognition, if not universal approval, just as Strachey's most famous book *Eminent Victorians* did in 1918. Both portrait and book herald a change in attitude to the written and painted biographies produced hitherto in Britain – Victorian hagiography was becoming a thing of the past.

The two men probably met in 1905 and Strachey, a homosexual, was immediately attracted to the handsome young artist. On his part, Lamb enjoyed the "stirring conversations" (Clements, p. 168) that they habitually had, for his was no mean intellect. Emotionally Strachey was more of a problem and Lamb teasingly held him at arm's length, despite Strachey's optimism that the long portrait sittings would change that situation.

Lamb's 'grandissimo', as he called it, is a truly enormous picture – the most ambitious project he had undertaken. Although its evolution was slow and alterations continued to be made to it until it was first exhibited in 1922, the overall design was fixed upon almost immediately. Strachey's figure fills only a quarter of the canvas and this makes an astonishing initial impact on the spectator, but in no way does it diminish Strachey's stature. This is because the geometry of the picture echoes his figure, and because the glazing bars on the window act as a second frame within the composition thus helping – along with his pose and Lamb's use of paler colours – to thrust him forward into the spectator's space. The elongated head gives further dominance to the figure while the nervous, yet calm, hands and the sprawling legs express the intellectual eagerness of the man: it is as if he is about to interject in the conversation. Yet, at the same time, one can understand why it has been considered close to caricature: near to, the figure looks like a statue hacked out in paint attached to a pair of collapsed legs. A mutual friend, Lady Ottoline Morrell, described him as "so dignified and serious" but also "so feminine, nervous, (and) hysterical" (Clements, p. 16). Lamb has captured this ambivalence. But looking at the portrait from the correct distance other qualities come to mind. Lytton Strachey appears eagerly gathered up in thought – "very silent, but uncannily quick and comprehending" (Clements, p. 197) as Diana Mosley later recalled. The large area of background amplifies the interpretation of character too; nothing is entirely natural, yet it is entirely appropriate to the sitter. The enormously exaggerated

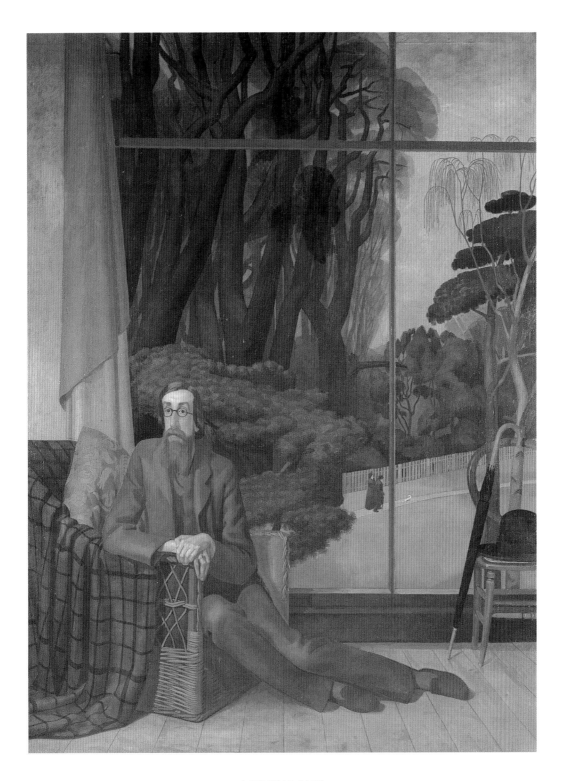

HENRY LAMB

Portrait of Lytton Strachey, 1914

window pane excludes us from total entry into Lytton Strachey's world while it also acts as a metaphor for his perspective onto the nineteenth century. The 'surrealistic' trees, too, echo the metaphors, colloquialisms, and daring of his prose, while the shiny black hat and umbrella are not easily taken at face value: to guy conventionality is part of Lytton Strachey's style and they are a reminder of this.

The self-possession and assurance evident in this painting look back perhaps to an era when the portraitist was not troubled by doubts about the validity of his perception. But here the assurance has to do not only with Lamb's confident assertions about the persona of his sitter, but also assertions of what it felt like to be Strachey, and of what Strachey felt in relation to the world around him. The questions it poses go deeper than a Sargent or Augustus John.

HENRY LAMB is described on his tombstone as "Painter, Doctor, Musician" (Manchester, p. 9). In addition he was an extremely well read and erudite man and a witty and entertaining conversationalist. Forced by his father to read medicine, he excelled at this but at the same time became a very accomplished musician, and a budding artist. By 1905 he decided to change career to that of painter. Always ill at ease with the 'Bloomsbury Group' — barring Lytton Strachey and Duncan Grant — he was particularly close to Augustus John and Stanley Spencer during the earlier part of his career. Portraiture played an important role in his work, though his townscapes and landscapes are also of significance. He was never one for bravura painting, and was an artist who usually presented a convincing and psychological likeness.

His later portraits tend towards the academic but those painted before the mid-1920s include striking examples. Of note too are his two paintings of the Great War which bear upon his experiences as a surgeon in Macedonia and Palestine.

Loathing dealers and the gossip of the art world he did, nevertheless, become a Trustee of the National Portrait Gallery (1942) and the Tate Gallery (1944). He was elected an Associate of the Royal Academy in 1940 and a full Academician in 1949.

BIBLIOGRAPHY

CLEMENTS, Keith *Henry Lamb, the Artist and his Friends* (1985)
HOLROYD, Michael *Lytton Strachey by Himself, a Self-Portrait* (Heinemann, 1971)
MANCHESTER CITY ART GALLERY *Henry Lamb* (May–June, 1984)
STRACHEY, Lytton *Eminent Victorians* (Introduction to the Penguin edition, Michael Holroyd, 1986)

Vanessa Bell (1879–1961)

Mrs St John Hutchinson, 1915

OIL ON BOARD, SIGNED
73.66 × 57.78 cm (29 × 22³/₄ ins)
TATE GALLERY, LONDON

Vanessa Bell belonged to the same social circle as Lytton Strachey and her behaviour and artistic leanings were also, by the standards of the time, startling. A remark made by the artist William Rothenstein in 1903 presages the astonishing leap in consciousness being made by her during the opening years of the twentieth century: "She looked as though she might have walked among the fair women of Burne-Jones's 'Golden Stairs'; but she spoke with the voice of Gaughin" (Shone, p. 22).

By 1915, the date of Mary Hutchinson's portrait, Vanessa had made enormous strides in her work and had become involved with three men central to that progress: her husband Clive Bell, her lover, Roger Fry, and her partner in painting – and in so much else – of nearly fifty years, Duncan Grant.

When placed besides more conventional portraits of the period by, say, John Singer Sargent or Sir John Lavery this picture appears glaringly avant-garde. The sitter's eyebrows are green, her face too is shaded with a blatant green, the whites of her eyes are painted blue, and she is dressed in an apple-green sack and placed in a nondescript pink space. The brushwork appears coarse and unfinished – indeed the result looks a mere sketch. In addition, she looks thoroughly discontented and glances warily at the artist. Vanessa Bell's reasons for painting such a portrait of Mary Hutchinson were twofold: above all she was interested in exploring current trends in art and, secondly, she was responding, in a subliminal manner, to this woman as her husband's mistress even though she herself also was embroiled in an extra-marital relationship. The affair had begun in 1915 and Vanessa Bell soon became uneasy when Mary entered their intimate 'Bloomsbury' circle. It was her taste and appearance that antagonised Vanessa most for she always looked so chic and poised, in sharp contrast to the painter's unstudied style. Before long Vanessa Bell wrote rather tartly to Lytton Strachey: "Mary I think is made for salons. Her exquisiteness is not lost upon us but it ought really to be seen by the polite world" (Spalding, 1983, p. 145). A comparison between this painting and a contemporary photograph says it all: Mary Hutchinson was by no means an outstanding beauty and her mouth was too big, but she was pretty and she did follow the Paris fashions. However, she was more than a society lady for, guided by her husband and then by Clive Bell, she had read widely and she would become the friend of T. S. Eliot and Aldous Huxley. She also wrote short stories and the occasional review. Admittedly Clive came to find long spells in her company irksome and, no doubt, her legendary composure was as unnerving to Vanessa as Vanessa's silent choking over emotional crises sometimes was to those around her.

But it is as an example of all that was new at the time this portrait was painted that also excites, for it is one of a number executed by the artist between 1912 and 1918 that

show her indebtedness to Roger Fry's dynamic Post-Impressionist exhibitions and revolutionary new theories on art. Fry was especially excited by Cézanne and Matisse, and Vanessa Bell's impulses ran parallel to his interpretations of their work. He talked of the "inner life" (Spalding, 1980, p. 147) shining through the arbitrary apricot face of Cézanne's *La Vieille au Chapelet*, and he praised Matisse's *Femme aux Yeux Verts* for its design and splendid colours while dismissing the absence of likeness in the face. As a portraitist, Vanessa had by 1912 dared to paint her family and friends with featureless faces yet, amazingly, the spirit of the sitter was conveyed with uncanny accuracy; her command of the human figure and her ability to make colour and brush strokes precise metaphors for likeness was such that she could take this licence. A whole new set of rules governing art had come into existence at exactly the moment when Vanessa was questioning the need for exactitude and narrative in painting. Fry sanctioned omission of detail and an entirely new way with colour and form for he believed in the validity of painting equivalents to life. Recalling the 1910 Post-Impressionist Exhibition years later Vanessa Bell commented: "it was as if one might say things one had always felt instead of trying to say things that other people told one to feel" (Spalding, 1983, p. 92).

In 1928 the portrait was exhibited and the sitter's name clearly labelled. Clive Bell, that other champion of the modern movement, was furious, clearly oscillating between his artistic beliefs and personal pressures. The exhibition had been arranged by Roger Fry who had once said: "it becomes almost part of (the portraitist's) duty to sacrifice something of aesthetic necessities to non-aesthetic demands" (Filby Gillespie, p. 163). However, Vanessa had abandoned this attitude early in her career.

In 1904 the Stephen's sisters (VANESSA BELL and Virginia Woolf) were freed, by their father's death, from the claustrophobia of polite society and henceforth they may be described as having embraced the philosophy of the 'new woman'. Encouraged by their brother Thoby's Cambridge friends – including Lytton Strachey and Clive Bell – they abandoned tea-table conventions and conversations for an intellectual and moral equality with these new companions. But it went further than that: both sisters had serious ambitions for their careers as artist and writer respectively.

Vanessa Bell had attended the Royal Academy Schools from 1901 to 1904 where she had worked extremely hard at drawing from the antique and from the human figure, and at anatomy, composition and perspective. But hers was a lively and questioning eye not long to be contented with the insularity of British art. While reading Ruskin on a visit to Italy at this time she commented: "He never cares for anything unless it is a symbol or has several deep meanings which doesn't seem to me what one wants" (Shone, p. 22).

More and more, as her friendships with the 'Bloomsbury' Group deepened, and after her marriage to one of them – Clive Bell – her criticisms of meaningless mimetic art grew. The year 1910 proved to be a turning point for Vanessa for it was then that her association (later to develop into a love affair) with the art historian Roger Fry began and in 1910, as he assembled the first of his two Post-Impressionist Exhibitions, she was able to listen to his 'revolutionary' theories on art. Until then Roger Fry had been more widely known as an expert and writer on Old Master paintings and as Curator of Painting at the Metropolitan Museum of Art, New York where, despite enhancing their feeble collection of nineteenth-century pictures through a succession of brilliant purchases, he

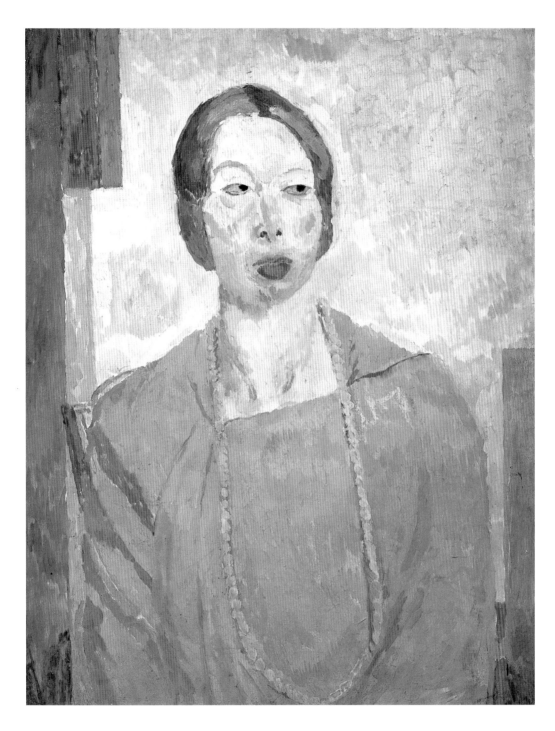

VANESSA BELL

Mrs St John Hutchinson, 1915

fell foul of its tyrannical President J. Pierpont Morgan.* Morgan only understood sycophants: even his sister, Fry noted on a visit to Italy with them, played to his tune by uttering well-timed "mouse-like squeals of admiration at pictures, scenery and Mr. Morgan's remarks" (Spalding, 1980, p. 102). But despite the difficulties of his curatorship, Fry had been developing his interest in contemporary art and in *An Essay on Aesthetics*, published the previous year, he had argued that to be great a painting had to exhibit more than just mimetic qualities, and both there and in his subsequent exhibitions he looked at and analysed the merits of Cézanne and Matisse in simple, forthright language.

If, as Quentin Bell has written, Fry's two exhibitions "destroyed the whole tissue of comfortable falsehoods on which that age based its views of beauty, propriety and decorum" (Spalding, 1980, p. 140), the culminating effect on Vanessa's life destroyed any tenuous links she may still have had with conforming Edwardian society. Always to remain close to Roger Fry she embarked in 1913 upon another, but more complicated, extra-marital relationship with the painter Duncan Grant which was to endure for the remainder of her life. At that point hers was arguably the more adventurous art for, although portraiture was an important part of it, elements of abstraction, an arbitrary use of colour, and an emphasis on decoration were among its central ingredients. By 1919, following the birth of their daughter Angelica, and her endeavours to accept Grant's unending need for homosexual affairs, domestic strains took their toll on Vanessa's painting. Although she was very much revered in artistic circles she ceased to be as audacious and exploratory as in the pre-war period. Nevertheless, the numerous paintings of Charleston Farmhouse in Sussex and of her intimate friends, together with her interior design work – done in conjunction with Duncan Grant – still exhibit her talent and inventiveness.

Belonging to a close-knit, intelligent, and in some senses mutually supportive group, and inheriting the assurance if not the conventions of her forebears, Vanessa exhibits the impatience with old, no longer adequate formulae, and the energetic search for new ones that characterise the better portraitists of the first half of the twentieth century. There is no sign in her, however, of the pessimism emerging so strongly in the second half of the century.

BIBLIOGRAPHY

DUNN, Jane *A Very Close Conspiracy: Vanessa Bell and Virginia Woolf* (Pimlico, 1990)
FILBY GILLESPIE, Diane *The Sisters' Arts: the Writing and Painting of Virginia Woolf and Vanessa Bell*
(Syracuse University Press, 1988)
SHONE, Richard *Bloomsbury Portraits: Vanessa Bell, Duncan Grant and their Circle* (Phaidon, 1976)
SPALDING, Frances *Roger Fry, Art and Life* (Elek, 1980)
Vanessa Bell (Weidenfeld & Nicholson, 1983)

* Roger Fry was, however, able to develop a good relationship with Morgan's chief legal adviser, John G. Johnson, and he helped him form his collection of Old Master and nineteenth-century French paintings which are now in the Philadelphia Museum of Art.

Sir William Orpen (1878–1931)

The Artist, 1917

OIL ON CANVAS
60.96 × 48.89 cm (24 × 19^1/$_2$ ins)
IMPERIAL WAR MUSEUM, LONDON

On the face of it Sir William Orpen led a successful and contented existence but, like Vanessa Bell, he was troubled by his domestic life. Throughout his career he returned, again and again, to the contemplation of his own face, but never did he reveal in his paintings of it the inner man, choosing rather to present himself playing a role. It becomes clear from reading his biography that Orpen did not wish to encounter head-on certain aspects of his character, or the problems arising from his marriage and his love affairs. Instead he kept up a front as a 'cheerful chappy' and when that failed him he reached for a whisky and soda. It is ironic that someone with the ability to record the horrors of the Great War so objectively could refuse to confront himself in similar manner.

The three self-portraits painted during his time as an Official War Artist in France show none of the "sudden growing up" (Arnold, p. 312) that he claimed was his experience there. The earlier couple portray him as younger than his years and as idealistic as his adored Tommies were – until they learned better – while *The Artist* shows him at work as an artist, but discloses little else about him. In it Orpen is dressed as an Army Major (which was his rank) out sketching the battlefield. He wears a tin helmet and under it a balaclava to ward off the cold, wet winter of 1917. These articles enclose his jaw and draw attention to his piercing gaze. That gaze is in communication with the scene before him feeding his pencil with information which he notes down with characteristic swiftness and clarity. The careless manner with which he has thrown on his greatcoat in the composition is markedly different from the way in which he describes army uniform in the commissioned military portraits of the period. Has he made himself look dashing to draw attention to his profession as artist? The picture certainly acts as a complement to his other war work in that it portrays him in his role as an observer and a recorder, yet it gives only a partial view of Orpen the man and thus it takes its place alongside earlier examples of him wearing a mask.[*]

By the time that this portrait was finished Orpen had painted a number of remarkable oils of the battlefields of Northern France. All are handled in his matter-of-fact style and are the work of the summer months of 1917. Many of these landscapes appear more like Mediterranean scenes, with intense blue skies and scorching white chalky ground, than the graveyards they in fact were. But then there is the potency of the silence and the stillness of the scene, and the un-emphasised ruined buildings and scattered skulls which prey upon the imagination. Writing about these experiences later, he talked of the "truly terrible peace in the new and terribly modern desert" (Arnold, p. 316).

[*] These include *The Jockey*, *The Man of Aran*, *The Dead Ptarmigan* and versions of him dressed à la Chardin – his artist-hero.

As well as the devastated land, Orpen painted the protagonists. He showed a marked sympathy for the common soldiers, describing with conviction their weariness, suffering and perplexity at the nature of this extraordinary war. His portraits of the military leaders on the other hand – Haig, French, Trenchard and so on – appear at first sight relaxed, open and immediate, but when set against those war paintings of Tommies very different qualities emerge. At the Paris Conference his opinion that the leaders of the War were fools crystallised, and in a remarkable series of canvases he quietly belittled the 'frocks', as he called them, by devoting the major part of his compositions to the splendid architecture of the Conference venues whilst relegating the participants to the bottom quarter of his canvases.[*] "He was a painter of the appearance of things and that isn't saying he was superficial, he painted what he saw with such love – he made no comment . . . he says what he sees, and it is shattering" (Arnold, p. 325). Beatrice Glenavy's helpful critique of the war work acts as a guide to Orpen's developing intentions. After these pictures had been exhibited at Agnew's in 1918 he offered them, as a corpus, to the nation. Only seen together can one understand the depth of the artist's criticism of the military leaders: their smart, clean, genial faces compare strikingly with those of the 'Tommies' – dead in the mud: they were the true heroes. Orpen took certain risks in his war paintings but then he was, on the surface, a joker and a teaser and he had friends in high places, which, paradoxically, may have deflected the deadliness of his attack.

It has been argued that Sir William Orpen produced his best and most serious work during the War and at the Peace Conference when the demands of 'society' portraiture were cast aside for a higher cause. This makes sense because some of his finest early portraits are of working folk – such as Lottie the washerwoman of Paradise Row – whose undemanding psyches, like those of the Tommies, engaged his affection and sympathy. He had also a few favourite models, including his wife Grace, and his pictures of them are extremely satisfying. However, Orpen's affinity and ease with such sitters was lost when he began to devote himself to commissioned work: these portraits have been rightly dismissed as mere "mechanical marvels" (Rothenstein, p. 226).

Sir John Rothenstein remembered his uncle as having "light grey eyes that observed much and revealed little" (Rothenstein, p. 212). But there is a deliberate guardedness in what Orpen observed. Even when he painted people who touched his heart he appeared to glance sideways and fleetingly at what was essential in them. And when painting his own face he either hid behind a persona, as in *The Artist*, or mocked himself; his mocking being especially apparent in the plethora of self-caricatures that litter his correspondence. If indeed he 'grew up' – as he wrote to his wife – on the battlefields of France this maturity never shows. Something is missing. The basic energy that fuels the human psyche was stopped up in him and could not feed the artist's eye. He did not wish to disclose his inner being to the world, to his friends, or even to himself. Finally he became unable to do so; he held everyone at bay, a not unusual practice for a man born in the Victorian era. The undeniable strain that this caused him may however have led to his early death from alcoholic poisoning – euphemistically described as overwork.

SIR WILLIAM ORPEN, the fourth son of an Irish Protestant solicitor, was born near Dublin at a sensitive moment in Irish history. He quickly learned to avoid discussing

[*] For a discussion about the fate of the third of these commissioned paintings see Bruce Arnold, *Orpen Mirror to an Age*, pp. 377–80.

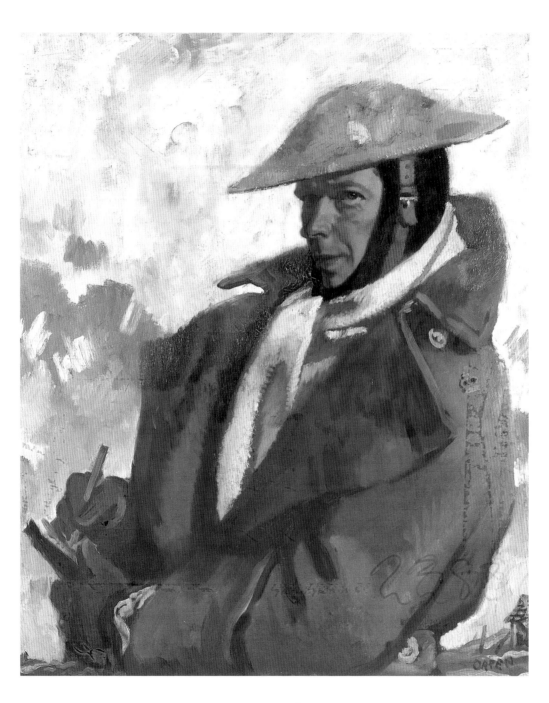

SIR WILLIAM ORPEN

The Artist, 1917

politics and because his talents led him to the Metropolitan School of Art, Dublin at the early age of thirteen, he missed his brothers' classical and legal educations: such educations can make the student find argument irresistible. In 1897 he moved on to the Slade School of Art where a fellow-student rated his abilities as those of "a one-man show" (Rothenstein, p. 215). Four years later he held his first exhibition in London and it was well-received. A third of the paintings on show were portraits and soon he began to obtain a steady flow of commissions.

In 1908 Orpen began an affair with Mrs St George, a rich American married to his cousin and living in the West of Ireland. She was the daughter of the legendary 'Sphinx of Wall Street', George F. Baker, the President of the First National Bank of New York. "That American" (Winch, p. 13), as the Irish would call her, was always fantastically dressed and unorthodox in everything she did. She was over six feet tall, towering above the diminutive Orpen allowing 'society' the tempting opportunity of referring to them as Jack and the Beanstalk. Forceful and fun she was good, and bad, for his future offering him patronage and introductions but, ultimately, too much work of the wrong sort. He became entangled in the treadmill of 'society' portraiture, both Irish and English, and lost contact with the simpler souls whose straightforwardness suited his talents better. From 1908 onwards his life became complicated for, true to his Victorian upbringing, he was not going to leave his wife despite their problems which, of course, were exacerbated by his affair. In letters to Mrs St George he talked of his increasing need to drink. In a series of self-portraits he dressed himself up and accentuated his ugliness. Self-mockery and disguise, coupled with drink, seemed to become the lietmotif of his life: unarguably successful in 'society's' terms, as the highest paid portraitist ever, he did not seem to dare to know himself.

For the late twentieth-century reader of Sir William Orpen's life there are many lacunae which may, or may not, get filled in years to come. Why did his marriage fail? What had happened to his relationship with Mrs. St. George by the outbreak of War? Why was his subsequent French mistress, Yvonne Aubicq 'paid-off' in the 1920s, and who was the fourth woman who supplanted her? All of this is not mere titillation for it clearly had a bearing on Orpen's career forcing him, in the inter-war years, to continue to churn out portraits to maintain his formidable earnings. The strain of carrying on as normal was certainly, even for a man who appeared to be constantly cheerful and jokey, difficult. Blood poisoning during the War together with a high intake of alcohol and cigarettes jeopardised his physical health. And although he continued to work hard, it was not just that but rather his hiding of the truth – and what to do about it – from himself that led to his early death at the age of fifty-three.

Because of his distaste for self-knowledge, and because he was chained to the treadmill of commissioned portraiture, and thus not free to paint only those sitters who excited his interest and engaged his sympathy, there is little evidence in Orpen's work of those forces which were beginning to change the nature of portraiture. A painter who locks up what he feels about the world in which he lives, and the people in it, diminishes the depth and range of perception he can focus on his sitters.

BIBLIOGRAPHY

ARNOLD, Bruce *Orpen Mirror to an Age* (Jonathan Cape, 1981)
ROTHENSTEIN, Sir John *Modern English Painters*, vol. I (Macdonald and James, 1976)
WINCH, Vivien *A Mirror for Mama* (MacDonald, 1965)

Augustus John (1878–1961)

Lady Ottoline Morrell, 1920

OIL ON CANVAS
66 × 48.5 cm (26 × 19 ins)
NATIONAL PORTRAIT GALLERY, LONDON

Of all the artists working in Britain during the first half of the twentieth century Augustus John's name is perhaps the most familiar. He shared with Lady Ottoline Morrell (1873–1938) the distinction of always being singled out in a crowd: both became legends in their lifetimes. Half-sister to the 6th Duke of Portland and wife of the Liberal MP Phillip Morrell, Lady Ottoline's unusual looks, early shyness, and dread of a future composed of "entertaining shooting parties, and living with a man to whom I could never talk" (Jobson Darroch, p. 28) led her to undertake a voracious programme of self-education seeking the spiritual advice of Mother Julian and of the Archbishop of York, later following this with equally intense, but more daring, friendships with Henry Asquith and Axel Munthe.

Thursday evenings 'At Home' in Bedford Square, and her open house at Garsington Manor, Oxfordshire made Lady Ottoline renowned. At Garsington the Morrells welcomed many of their artist friends as conscientious objectors during the First World War. "Why is it that yesterday we called death by another man's hand murder or manslaughter, now it is called glorious bravery and valour?" (Jobson Darroch, p. 14) she later wrote. At both houses she sought to nurture talent recognising how hard it is for unknown artists or writers to get known, let alone live, and her visitors' book boasted the names of Mark Gertler, Henry Lamb, Lytton Strachey, Bertrand Russell, D. H. Lawrence and others. Roger Fry talked of her "real feeling for art" (Jobson Darroch, p. 73), and he and the Morrells were among the founding members of the Contemporary Art Society whose aim was to buy and exhibit the work of young artists.

In 1908 Augustus John, physically fearless and wildly romantic, known as a cohort of the gypsies, as a philanderer, and as the most brilliant draughtsman since Michelangelo, sat one evening in conventional dinner attire next to Lady Ottoline Morrell. He hypnotised her; he was her idea of genius. In turn, he found her very different from the models and barmaids he so often associated with but, in common with the best of them, she radiated mystery and was a compulsive listener: he needed these qualities in a woman. John immediately asked her to sit for him. During the course of these sittings they became lovers and they were always to remain friends. He drew Lady Ottoline many times that year but did not exhibit, let alone complete, this oil painting of her until after the war. It was shown in 1920 and savaged by the critics. Everyman wrote: "That curiously Elizabethan Lady Ottoline Morrell is even more unpleasantly snake-like and snarling. It may puzzle one to imagine why society women should like to see themselves painted like this, even by Mr. John" (Jobson Darroch, p. 235). She was not upset by the picture, and later bought it from the artist, which is of interest for she could react very hysterically if she felt she was being ridiculed – a notable occasion being when D. H. Lawrence

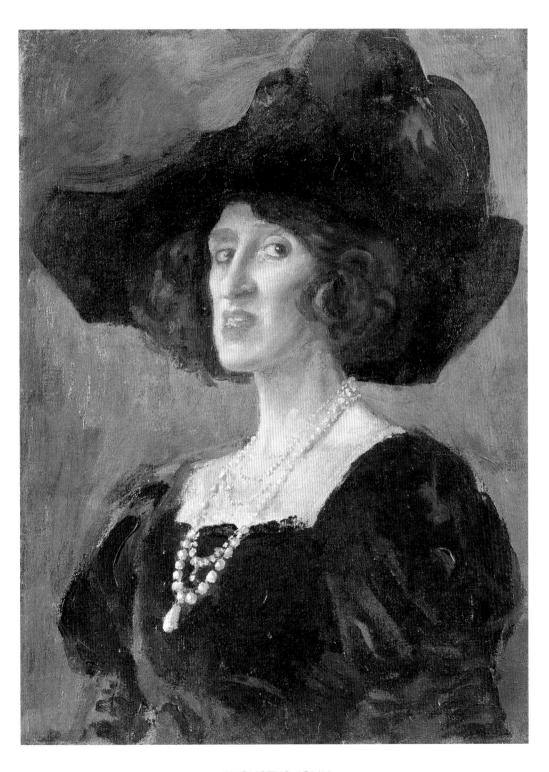

AUGUSTUS JOHN

Lady Ottoline Morrell, 1920

modelled Hermione Roddice on her in *Women in Love*: but his portrait is a distortion and does ridicule her, John's does not.

Augustus John was at his best when painting women who bewitched him in some way and this portrait is much greater than the caricature it was accused of being. Not only does it capture the obvious, her aristocratic lineage, but John has described the oscillation in Lady Ottoline's nature between puritanism and romanticism. On the one hand she parries communication, on the other she is possessed of a wild energy and yearning to escape from the confines of conventionality. The portrait dates from the post-war years, as her hair was bobbed in 1919, yet she wears dress belonging to the Edwardian era, and would continue to defy fashion. Her head is finely modelled, displaying John's drawing skills, then the brush sweeps paint over her dress and onto the background in more careless fashion. No indication is given by way of props or setting of her surroundings or her interests, instead a complex aura of interests and excitement is concentrated in her flamboyant hat. It has a life of its own and she has chosen it just as she had chosen to break away from smart society. The portrait is typically romantic, concentrating on her personality and, arguably, presenting it histrionically if it is compared with the series of drawings and watercolours John did of her dated 1908.

Such was AUGUSTUS JOHN's fame by the 1920s that even the restauranteurs of Soho were naming their entrecôtes, *à la John*. Perhaps this is a small indicator of the uncertain quality in his art; he had much talent but little staying power and could ruin a picture as quickly as a steak could be overcooked. Never was he more honest than when he said, "Fifty years after my death I shall be remembered as Gwen John's brother" (Holroyd, p. 80). Indeed, by 1919 his most important patron the New York lawyer John Quinn was bemoaning the fact that an artist with so much talent had lost his way.

During adolescence Augustus John cast off the precepts of youth, preferring a bohemian existence to the cramped morality of his father's home. But the breakaway was never sufficiently complete; it was a backward-looking revolt in that the prime element was hatred of paternal restrictions, not a forward-looking vision of what freedom really was. He was too intent on fighting the enemy, so never escaped. Thenceforward he was caught up in an identity crisis of his own making which became exacerbated whenever he was, or thought he was, constrained by anybody or anything. Often, during portrait commissions, a wild panic would break out in him and the picture would become dull and hurried. He relied too often on flair and admitted as much. If, as Laurence Binyon put it, "He is limited, obsessed by a few types . . . his ideas are few . . . (and yet in his work) there is a jet of elemental energy, something powerful and unaccountable, like life itself" (Holroyd, p. 433), then this is manifested most clearly, when it comes to portraiture, in pictures of 'creators' and in ones of his favourite women – including Lady Ottoline Morrell who, indeed, shared with him this terror of being trapped.*

Never can Augustus John be categorised as a 'society' portrait painter – his behaviour and his commitment were too idiosyncratic for that. But the genre did occupy a lot of his time – especially in moments of financial need. And he complained that it kept him from his major preoccupation – the painting of large narrative compositions – which was, maybe, just as well as they tend to lack intellectual and dramatic substance.

* Among the 'creators' he painted were W. B. Yeats, Wyndham Lewis and Matthew Smith.

Augustus John is a compelling example of a painter whose own personality determines the nature of the portrait quite as much as the personality of the sitter does. He is as much there in his portraits as Orpen is absent in his, and both absence and presence qualify the work. This pervading presence of the artist's emotions and preoccupations becomes more pronounced as the century advances. Such portraits by a gifted artist can be very powerful but they never achieve the element of universality that comes when everything the man is, is focused exclusively into an awareness of the object he paints.

BIBLIOGRAPHY

CONTEMPORARY ART SOCIETY *British Contemporary Art 1910– 1990* (Herbert Press/CAS, 1991)
DALHOUSIE ART GALLERY, CANADA *Augustus John* (1972)
EASTON, Malcolm and HOLROYD, Michael *The Art of Augustus John* (Secker & Warburg, 1994)
HOLROYD, Michael *Augustus John* (Penguin, 1976)
JOBSON DARROCH, Sandra *The Life of Lady Ottoline Morrell* (Chatto & Windus, 1976)
REID, B. L. *The Man from New York: John Quinn and his Friends* (Oxford University Press, 1968)

Sir William Nicholson (1872–1949)

Miss Gertrude Jekyll, 1920

OIL ON CANVAS; SIGNED AND DATED

76.2 × 76.2 cm (30 × 30 ins)

NATIONAL PORTRAIT GALLERY, LONDON

If Augustus John is remembered as the stereotype of the modern artist – flamboyant, unreliable and very gifted – his contemporary, Sir William Nicholson, is in his understated way the more 'advanced' artist of the two, not only in his printmaking but in his attitude to the painting of a face. In person he seems a conventional, restrained, private individual but, in fact, he was much more sensitive than John to the influences that were beginning to alter the human consciousness. In his woodcut of Queen Victoria (see p. 103) he perceived both the loneliness and the monumental nature of the old monarch which is never apparent in any other picture of her. In the same way he immediately grasped (and makes the viewer see) the unique commitments of Gertrude Jekyll which are quite impervious to the conventions of her time.

In 1897, the year of Queen Victoria's Golden Jubilee, Nicholson and Gertrude Jekyll achieved fame, the one for his bold woodcut of the Queen, the other in recognition of her pre-eminence as a gardener. Nicholson's print, made to commemorate the Jubilee, was published in *The New Review* and hailed by critics as a "triumphant success" (Campbell, p. 172). It was considered by some to be by far the most important portrait of the sovereign ever to have been seen. Miss Jekyll, meanwhile, had been awarded the Victoria Medal by the Royal Horticultural Society – one of only two women by 1897 to have been honoured with it. Twenty years later the two met and Nicholson was soon commissioned by their mutual friend, Sir Edwin Lutyens, to paint a portrait of the elderly lady. Reluctantly she yielded to their persuasion and, once more, the artist created an evocative picture of old age and character.

Sir Edwin Lutyens had been introduced to Miss Gertrude Jekyll in 1889. "We met," he later recalled, "at a tea-table, the silver kettle and the conversation reflecting rhododendrons. She was dressed in what I learnt later to be her Go-To-Meeting Frock – a bunch of cloaked propriety topped by a black felt hat, turned down in front and up behind, from which sprang alert black cock's tail feathers curving and ever prancing forwards" (Brown, p. 32). But this irreverent picture, by a young and aspiring architect a generation her junior, belies the close rapport that was to grow up between them. By the mid-1890s their 'partnership' – for it can be described in no other terms – had cut its teeth on Miss Jekyll's new house, Munstead Wood, with Jekyll planning its garden and Lutyens the house. They were sufficiently friendly by now for Lutyens to bring his fiancée, Lady Emily Lytton, to meet Gertrude Jekyll. In a letter describing this event Emily wrote: "She is the most enchanting person and lives in the most fascinating cottage you ever saw. Mr. Lutyens calls her Bumps, and it is a very good name. She is very fat and stumpy, dresses rather like a man, little tiny eyes, very nearly blind, and big spectacles. She is simply fascinating" (Brown, p. 63).

Gertrude Jekyll (1843–1932) had already accumulated a multitude of interests and

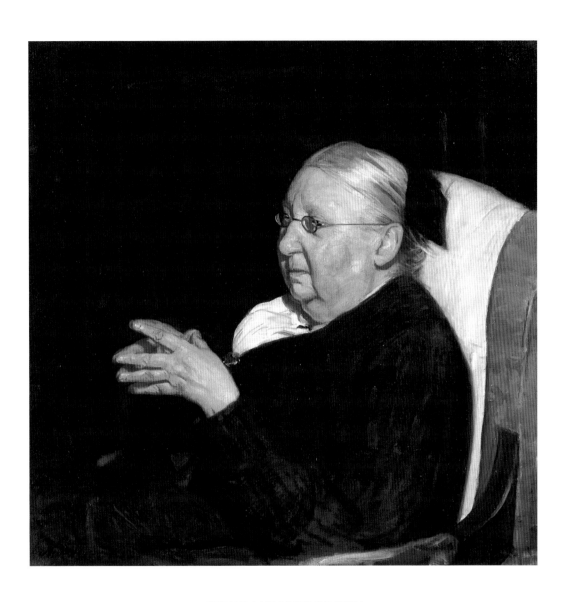

SIR WILLIAM NICHOLSON
Miss Gertrude Jekyll, 1920

skills by the time she and Edwin Lutyens sat down to tea. Her 'progressive' parents had allowed her to study painting at the newly opened School of Art in Kensington. She had joined the band of Ruskin's admirers agreeing with him that it was necessary to do things with her own hands till she understood all the difficulties involved. This led her into silverwork, woodwork, embroidery, gardening, country skills such as thatching, and into interior design when, in the 1870s, the Duke of Westminster appointed her "umpire-in-chief" (Festing, p. 79) at Eaton Hall which was under-going extensive refurbishment. Fuelling this bustle of interests was a tremendous energy and an eager and curious mind: Jekyll was always to fill her days to capacity – even in her late eighties she read a hundred books a year.

Since early childhood the Surrey landscape and her parents garden had been a source of fascination for her. As a small girl she had learned to name and classify flowers and plants. Later, she was inspired by the lawyer, philosopher and man of letters, Francis Bacon, who had believed that a garden should be, above all, "a place of quiet beauty, delight for the eye and repose and replenishment for the mind" (Brown, p. 97). By the time that Munstead Wood was completed Jekyll and Lutyens had settled into a pattern of working together. In the early days of their 'partnership' she would frequently introduce him to a client and then he would ask for her advice on the garden. Gertrude Jekyll used to comment too on all Lutyens's plans, which delighted her for it was "very nice for me as I have a passion, though an ignorant one, for matters concerning domestic architecture that almost equals my interest in plants and trees" (*TLS*, 20 December 1991).

In addition to this fruitful association, Gertrude Jekyll had forged links with the editors of *The Garden* and *Country Life* and continued to write articles of great importance for them for many years. She was equally prolific as an author of books and her views on the cultivation of gardens and the treatment of the countryside are read today with renewed interest.

When Edwin Lutyens persuaded Miss Jekyll to sit for her portrait by William Nicholson in 1920 the two men had known each other for many years. Each had drawn on the other's talents for several commissions too. It seems that Lutyens introduced Gertrude Jekyll to Nicholson in 1916 during a summer spent at one of his most famous architectural creations, Folly Farm. During this relaxed family holiday Nicholson came over to paint some murals in the dining-room and Miss Jekyll made a rare trip from home to help with the garden plans. Clearly the occasion was a happy one: in the evenings the old lady took off her heavy army-style gardening boots to play on the pianola.

As a person Gertrude Jekyll exuded confidence, but her appearance always caused her discomfiture. Therefore to have agreed to be painted was a brave decision which only someone like William Nicholson, with his great interest in characters and with his charming ways, could have won her round to. Having consented to the sittings she still continued to bargain over conditions, arguing that daylight hours were too precious to be wasted on portraiture. Eventually Nicholson agreed to paint her in the evenings as she sat in her chair by the fire. During the day he, too, refused to remain idle: he painted his memorable still-life of her gardening boots as a present for Lutyens's wife Emily.

There must have been much that the artist and his sitter could have discussed during the progress of the portrait. She was an omnivorous reader, he numbered Kipling and J. M. Barrie amongst his close friends. Both could talk about art and, of course,

Nicholson's flowerpieces could not have failed to have met with her approval. Above all, there was their affection for their mutual friend Edwin Lutyens.

Like Emily Lytton years before, William Nicholson immediately realised that Miss Jekyll's plain, dowdy appearance was besides the point: her character and mind were everything. The portrait is very carefully composed to emphasise this. Of course she had to be seated because of her age but Nicholson used this to take attention away from her plump torso leaving it (rather as he did with the *Queen Victoria* woodcut) as a dark shape. He draws attention instead to her hands and to her face. Her hands are a mixture of the practical and the refined; they are thinking hands placed just so to make this point, for it is as if she is talking – explaining and gently teaching as was her wont, quite naturally, to do. Yes, her face is chubby and her chin sags but the tiny spectacles (quite different from the ones Emily Lytton remembered), the thin, shiny, silvery hair and the black bow in her bun, all express an emphatic, unique, endlessly inquiring personality.

Throughout his working life William Nicholson had a love-hate relationship with the art of portraiture. His famous woodcut of *Queen Victoria* was made so that he could jump on the band-wagon of the Jubilee celebrations. It and other woodcut portraits made him, by 1900, well known in Britain and in the United States. In 1900 he sent a woodcut portrait of the American President, William McKinsey to Harper & Brothers in New York. They liked it and it was published on the cover of *Harper's Weekly* on 30th June. Following this Nicholson was invited to depict other distinguished Americans for the magazine and spent three months in New York carrying out the work. But such prints did not remain financially rewarding, and as Nicholson had growing family responsibilities, he had to turn to painting portraits – a lucrative profession during the Edwardian era. During his career the profitability of the genre ebbed and flowed according to the political mood of the country. When confronted with the dull faces of businessmen, politicians or society beauties Nicholson's enthusiasm for the practice ebbed too. In the year of the Jekyll commission he wrote to his daughter: "My bank is getting restive and I must go to Town next week to scare up a faded beauty who I have promised to paint for money" (Campbell, p. 137). Yet, if his sitter was a friend or an amusing character, the occasion was transformed into a pleasure. Basically, he needed time to use his eyes and to allow a rapport to develop between himself and his subject. This gave personal idiosyncracies a chance to reveal themselves and allowed the composition to be natural and true to his vision of the sitter.

Dressed in "spotless" white ducks and socks and with shiny, "ever so shiny" (Kennedy North, p. 8) patent leather shoes on his feet SIR WILLIAM NICHOLSON did not conform to the conventional notion of a painter. However, from the moment he came to the attention of J. M. Whistler in 1896 – with his woodcut of the Prince of Wales's Derby winner Persimmon – until his death, he produced a body of outstanding work. Of it the critic Edward Lucie-Smith has written: "The essence of his art lay, not in his reactions to ideas, but in the way in which he confronted the visible world," an observation made even more explicit by Whistler's early words of admiration for the artist's ability to see the essential elements of a composition and to ignore the superfluous ones: "This art of leaving out is proof of the perfect acquaintance with the art of putting in" (*Art & Artists*).

From his clothes to his character and manners William Nicholson can be described

as the quintessential English gentleman. Courteous, charming, hospitable, he was also deeply emotional in his reactions to people and to his surroundings. Yet, most of the time, such feelings were contained behind a stiff upper lip, only exhibiting themselves in his art. Unless all was well with him psychologically he could not paint with any flair, and to paint well he needed familiar surroundings – his friends, family – and time in which to look carefully at the world and select from it some enchanting composition. Often his audience were surprised by the usual, for frequently Nicholson would see the unusual in it.

William Nicholson's father was one of a breed of successful Victorian industrialists who became Members of Parliament. His son, however, from an early age, preferred looking at things and drawing them. He married Mabel Pryde, an artist, and collaborated with her brother James on a series of fin-de-siècle posters under the pseudonym of the Beggarstaff Brothers. After Mabel's death in 1918 he married a war widow, Edith Stuart-Wortley, who was well off and because of his improved financial position he was able to spend more time painting landscapes and still-lifes, the latter described as "delicious in texture and colour" (*Art & Artists*). The advent of a second family encouraged him to do more print-making and illustrating. Always interested in literature, he did work for his friends Siegfried Sassoon and W. H. Davies. In the 1930s Nicholson often painted with Winston Churchill at Chartwell during Churchill's political interregnum. The Spanish landscape was another source of inspiration at this period. But upon the outbreak of war in 1939 he remarked: "That knocks *us* out" (Steen, p. 215), knowing that painting, and especially portraiture, would be a luxury few could afford any more. Unsettled by the war he gradually painted less and less and no work is recorded by him after 1942.

As Whistler and Lucie-Smith point out, Nicholson is one of those timeless artists whose perception of their object is not deflected by any extraneous preoccupations either to do with the world they live in, their own emotional complexities, or a need to express their own personality. Judgement is absent: the preoccupations, complications and personality they respond to are those of their sitter.

BIBLIOGRAPHY

ART & ARTISTS William Nicholson [Edward Lucie-Smith] (September 1980)
ARTS COUNCIL *William Nicholson Paintings, Drawings and Prints* [Introduced by Duncan Robinson] (1980)
BROWN, Jane *Gardens of a Golden Afternoon* (Allen Lane, 1982)
BROWSE, Lillian *William Nicholson* (Rupert Hart-Davis, 1956)
CAMPBELL, Colin *William Nicholson: The Graphic Work* (Barrie & Jenkins, 1992)
FESTING, Sally *Gertrude Jekyll* (Viking, 1991)
KENNEDY NORTH, S. *Contemporary British Artists: William Nicholson* (Ernest Benn, 1923)
STEEN, Marguerite *William Nicholson* (Collins, 1943)
TIMES LITERARY SUPPLEMENT 20 December 1991

Sir John Lavery (1856–1941)

Hazel in Rose and Grey, c. 1920

OIL ON CANVAS
127 × 101.6 cm (50 × 40 ins)
BARBICAN ART GALLERY, LONDON

Sir John Lavery is the opposite of an aesthetic milestone. To be painted by him was considered, in 'society's' terms, to have arrived.

In 1909 he married Hazel Martyn (1880–1935), daughter of Edward Jenner Martyn who had risen to be Vice President of Armour & Co. in Chicago, the leading meat packing firm in the United States of America. The Chicago 'Blue Book' listed the Martyns as one of the 400 'best' families in the city and when Hazel 'came out' in 1899 she was described as an "astonishing" beauty. However, having spent time in Europe, she had come by then to find Chicago vulgar and modern and yearned to return to Paris to continue with her art studies: in these she had shown promise. It was on a painting holiday in Brittany in 1903 that she met Lavery and benefited from his criticisms of her work. Within days of their first encounter they had fallen in love – he was twenty-four years her senior. Their courtship lasted six years during which time Hazel's widowed mother pushed her into marriage with a more suitable, younger man. In despair, on her wedding day, Hazel wrote to Lavery: "I am yours . . . I love you supremely" (McCoole, p. 19). The sudden death of her husband, her near-death in childbirth, and her last-minute rejection of another fiancé set the tone for the sort of dramas and tragedies that were to pursue Hazel through her life. John Lavery summed her up shortly before their marriage when he wrote: "Yes Hazel dear where you are there is danger, I know, still I believe one would get accustomed to it in time" (McCoole, p. 32).

By 1911 Hazel had become one of the best known women in English society described as "one of those Londonised Americans who are adept hostesses" (McCoole, p. 51). She drew many into her circle – the Prime Minister Henry Asquith, Winston Churchill, G. B. Shaw, J. M. Barrie – rulers, writers, soldiers and artists, creating a salon at the family home in Cromwell Place. She became her husband's most constant model and his muse, her artistic understanding and her boundless energy ensuring that the couple's activities remained always the focus of public attention. Her talents perfectly complemented Lavery's as an article written about her in the early 1920s shows: "As hostess, Lady Lavery more often sets the pace in originality than follows, and she even finds time to take a hand at moulding feminine fashions. Her gowns invariably bear the mark of her own artistic personality. She was the first to wear a wreath of golden leaves in her hair which London greedily copied, and her experiments in rose-pink and in rose-red evening gowns were eagerly adopted by fashionable dress-makers. In furnishing her home, she leads the prevailing modes, and new touches often find their way from within her walls to the rest of the world" (McKonkey, p. 142).

By the time that *Hazel in Rose and Grey* (known in Lavery's autobiography as *Hazel: Portrait in a Mirror*) was painted she was in her early forties, though she only

admitted to being seven years younger. The direction of her life was shifting: the elegant hostess was emerging as something of an *éminence grise* in the cause of Irish Nationalism. Edward Martyn had been proud of his Irish ancestry but his Irish-born son-in-law and his daughter were to become totally absorbed by Ireland. Thinking that political reconciliation might be helped by painting the portraits of both sides in the Home Rule argument, Lavery soon found himself recording the Casement Trial which followed the 1916 Easter Rising. While he worked Hazel sat in the court listening to the case and before long they both came to know the political activists who were involved. By 1920 Irish politics were, and would remain, Hazel's chief interest and because of Lavery's 'painterly diplomacy' the couple felt Cromwell Place could serve as a neutral meeting-ground during the Peace Treaty negotiations. It was now that Hazel came to know Michael Collins, the most charismatic of the Irish Nationalists, and it is most likely that their great love for each other was consummated during the following months and that he, in the words of G. B. Shaw, became her "Sunday husband" (McCoole, p. 102). Undoubtedly, Hazel had an influence on his attitude to the Treaty tempering his demands and thereby putting him at odds with Eamonn de Valéra: what some may have called pragmatism would lead to Collins's murder. Indeed their liaison, along with Hazel's unofficial role as a go-between put her life in danger too.

Meanwhile, Lavery painted his wife's portrait (one of over forty he did of her) showing her up-to-the-minute interest in fashion: tinted hair, make-up, and a pose whose only intention is to show off her clothes. But the hard artificiality of the portrait does small justice to the fact that "she lived on a much wider front, full of heart and intelligence, so that there is no milieu where she would not have enriched and adorned" (McCoole, p. 174). It was this, as well as her attractiveness, that drew Michael Collins to her.* As was so often the case, this aspect of a personality was not of paramount interest to Lavery, he cared much more for decorative effects and beautiful brushwork. Indeed the picture epitomises what Sickert once described as "the wriggle and chiffon school", a strain of female portraiture practised during the first quarter of this century which showed women at their most vacuous. This aspect of Lavery's work was pinpointed by the critic D. S. MacColl in the *Spectator*. Writing there in 1895 he said: "When he paints a pretty woman, he seizes upon one or two obvious points of likeness, fixes the general allure of the figure, and makes a striking assertion of the éclat of fair flesh . . . A painter who can imagine the beautiful harmony of colour in the draperies of one of these portraits, and whose appreciation of the principles of picture making is evidently so high, owes it to his talent to try for other virtues" (McKonkey, p. 106). That Lavery was aware of such habitual shortcomings in his portraits is evident from a remark he made in his Memoirs: "I have felt ashamed of having spent my life trying to please sitters and make friends instead of telling the truth and making enemies" (Leicester, p. 3).

Reading this autobiography one wonders whether in fact Lavery was capable of "telling the truth." His childhood and adolescence were peripatetic and disorganised, the story of his life contains frequent omissions and inaccuracies, and after a while the reader begins to suspect that these uncertainties are not accidental, that Lavery habitually blocked from his consciousness whatever was threatening or painful. This suspicion grows when he says of the bullfights he attended in Madrid that "only colour and its plots"

* After Collins's murder in 1922 Hazel was much comforted by his friend and political ally, Kevin O'Higgins. He, too, fell deeply in love with her; he, too, was murdered.

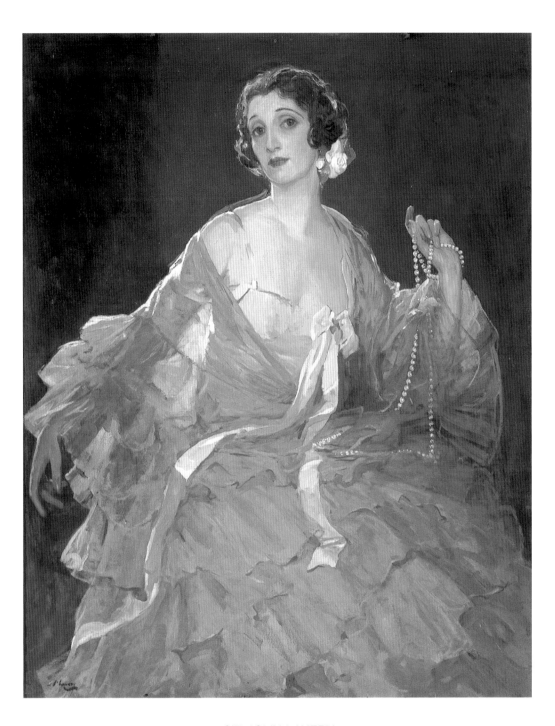

SIR JOHN LAVERY

Hazel in Rose and Grey, c. 1920

(McKonkey, p. 86) remained before his eye: nothing of the horror. Ironically, in *The Unfinished Harmony* (1934) his inability to tell the truth, when painting his dying wife, worked in both their favours. Aged only fifty-four Hazel's looks were suddenly ravished by illness and she refused to be seen by the outside world any more. Lavery, in constant attendance in her sick-room, was full of disbelief. To ease his (customary) silent suffering he painted the picture because, he said, "the colouring of the room appealed to me" (McKonkey, p. ·190): the grimness of death – for both of them – was conveniently hidden in a swirl of drapery. An artist who allows himself to be aware only of the pretty superficialities of life, who refuses to: "lie down where all the ladders start/In the foul rag-and-bone shop of the heart" no longer has the option of "telling the truth".* Little wonder that his paintings of the human face are unsatisfactory.

SIR JOHN LAVERY'S depth as an artist may be strictly limited but his range is not. He was a society portraitist, a painter of interiors, a war artist, a painter of far-off places and of country scenes. Above all he was a romantic, sometimes in his choice of sitter and in the adventurous travels he undertook in North Africa.

Following his unsettled upbringing Lavery decided upon an artistic career and from its inception he was characterised as both ambitious and modest. By 1881 he had acquired a dealer in Glasgow and through his services Lavery managed to finance a period of training in Paris. Back in Glasgow, in the mid-1880s, he became associated with a group of modern artists known as the Glasgow Boys. Their work was noticed by the critics and exhibited beyond the city boundaries. This, coupled with a commission to paint the State Visit of Queen Victoria to Glasgow for the International Exhibition, sealed Lavery's artistic fate. Portrait and genre scenes for the middle-class industrialists of the city – including the Burrell family – gave way over the next decade to a swelling Continental portrait practice. Correspondingly his circle of friends and acquaintances grew, among them the flamboyant adventurer and laird of Gartmore, R. B. Cunninghame Graham who appealed to the romantic strain in Lavery's character, whilst Winston Churchill, amongst others, aided his entrée into London society.

On occasions Lavery was daring and modern in his choice of subjects. The memorable *Tennis Party* of 1887, showing genteel ladies playing the game, was described by contemporaries as vulgar, while the strident colours and bold pose used to depict the dancer Anna Pavlova, in 1911, were considered as scandalous as anything shown in Roger Fry's Post-Impressionist exhibition of the previous year. Predictably however, Lavery, unwilling to make enemies, retreated from the controversy aroused by such pictures.

Sir John Lavery's attitude to painting and to his abilities are most vividly captured by his friend R. B. Cunninghame Graham: "The person who is being painted chats with her friends, doors close and open, a visitor has forgotten she left her husband sitting in a shop and screeches down the telephone . . . scents, noise, confusion . . . *Lavery sits painting on*. He answers everyone with a smile . . . not in the least regarding what they say . . . *and still the picture grows*" (Leicester, p. 3).

Nothing could describe more clearly than this that Lavery was, above all, more of a reporter on life than a searching commentator. Unlike Nicholson and John, and more willingly than Orpen, he was the slave of professional portraiture which added to the

* W. B. Yeats, 'The Circus Animals' Desertion', *Collected Poems* (paperback edn. 1982, p. 392).

comfort of the lifestyle that Hazel had chosen for them. The high esteem in which he was held – and consequently his inclusion here – indicate how slow the general public can be to recognise what is worn out, and to respond to the vigour of new, authentic perspectives. The discomfort of such perspectives can be sharp: the man-in-the-street tends to resist them unless driven by an even sharper need. It took another war, here on our doorstep, to drive home the sense of our inward and outward fragility and to ask that a portrait show more than the prettinesses and complacencies of life.

BIBLIOGRAPHY

BILLCLIFFE, Roger *The Glasgow Boys* (John Murray, 1985)

LAVERY, Sir John *The Life of a Painter* (Cassell and Company Ltd, 1941)

LEICESTER GALLERIES *Memorial Exhibition* (1941)

McCOOLE, Sinéad *Hazel: a Life of Lady Lavery 1880–1935* (Lilliput Press, 1996)

McCONKEY, Kenneth *Sir John Lavery* (Canongate Press, Edinburgh, 1993)

UNIVERSITY OF ST. ANDREWS, CRAWFORD CENTRE FOR THE ARTS *John Lavery the Early Career 1880–1895* (April–May 1983)

ULSTER MUSEUM/FINE ART SOCIETY *Sir John Lavery 1856–1941* (Exhibition 1984–1985)

Walter Sickert (1860–1942)

Hugh Walpole, 1929

OIL ON CANVAS; SIGNED AND DATED
76.2 × 63.5 cm (30 × 25 ins)
CITY ART GALLERY AND MUSEUM, GLASGOW

From the time of the Great War and until his death in 1941 Hugh Walpole (1884–1941) was a best-selling novelist, now remembered in particular for his *Rogue Herries* series set in his beloved Cumberland. Enthusiastic and compulsive in everything he did he formed an impressive library and also amassed a collection of over 1,000 pictures, prints and pieces of sculpture ranging in date from the Renaissance to the modern, but concentrated especially on British and French art. Any dealer knocking at his door was virtually guaranteed a sale; indeed Walpole wrote during the Blitz: "I believe I shall be creeping up Bond Street to look at pictures even while Hitler is making his triumphant entry into London" (Hart-Davis, p. 423).

Given this interest in the arts it is hardly surprising that Walpole had come to write the Preface to the Savile Gallery's 1928 exhibition catalogue of Walter Sickert's work: in it he had remarked that, for him, most modern portraits were "insipid and without character" (Savile Gallery) when placed besides those of Sickert. Unlike the pedestrian Lavery, Sickert had never stood still in his exploration of human behaviour, indeed the strength of his vision accords well with the tortuous twists and turns of contemporary life and the bewildered inward response of people to these events.

In October 1928 the artist was commissioned to paint the writer's portrait. Usually this was a situation avoided by Sickert for there was always, in his mind, a sterile conformity attached to commissioned work. Years earlier he had warned his friend Philip Wilson Steer to keep away from painting "well-chosen young persons" (Shone, p. 52) and had spoken disparagingly of the "bravura of the décolleté". However, he had always numbered writers among his circle and warmed to their way of seeing pictures. Now, as Walpole sat to him, he discussed once again the perils attached to lengthy sittings such as Sir William Orpen and Sir Gerald Kelly would demand. The novelist recorded the gist of their conversation: "Having got the spirit of the sitter in a drawing or two, surely they've got everything and can paint the rest as they please when they please. So Sickert does his little drawing, takes a photograph, and then the rest is 'his affair', not at all the sitter's" (Sutton, p. 231).

By now Sickert was coming to rely less on drawings: he would sit and observe his subject and often paint directly onto the canvas: in addition he was using photographs increasingly as primary evidence for a portrait. In 1912 he had argued that the camera "may be an excellent occasional servant to the draughtsman *which only he may use who can do without it*" (my italics) (Baron, p. 168). By 1929 he had come to consider the photograph as "the most precious document" (ibid.) for an artist, yet it was perfectly clear that he was only using it to extend his range of possibilities: to challenge his eye against that of the camera and thereby see from a different perspective, shapes and the fall of light.

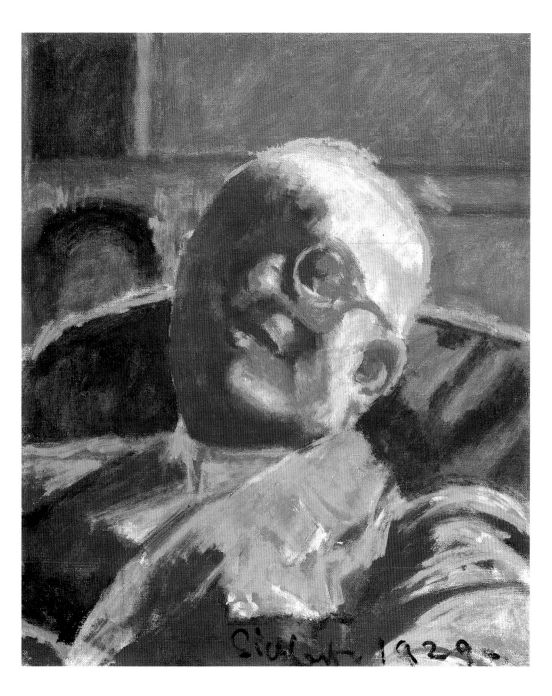

WALTER SICKERT

Hugh Walpole, 1929

Two portraits of Hugh Walpole resulted from the encounters in Sickert's Islington studio: the commissioned picture now in the Fitzwilliam Museum, Cambridge for which, according to Walpole, no photographs were used, and this picture which was done for Sickert's own pleasure in 1929 and is based on a photograph.

In an essay written some years previously the painter had spoken of the overwhelming and immediate urge to capture a face that could occur sometimes for an artist and he had explained that this made him determined to note such a physiognomy, "before the fizziness in (the subject's) . . . momentary mood has become still and flat . . . " (Sitwell, p. xix). Here it is as if that "fizziness" has been captured by the camera and then Sickert has enjoyed the more deliberate translation into coloured shapes governed by exciting, mysterious pools of light and shade that has followed. Despite the fact that an entire side of the face remains undefined there is a cogent physical presence. Walpole appears lively and alert and engaged in conversation, a conversation not difficult for either man to sustain, both having such a boundless enjoyment of life, both delighting in talk. In this version of the portrait Sickert has captured what has been described as an element of naive childishness in the novelist and he implies, too, the Mr Pooterish side of Walpole's character, so adept at minor mishaps. Dr Wendy Baron has described the picture as "one of the most convincing and exciting portraits of this century" (Arts Council, p. 32) but at all stages of his career Walter Sickert could be an innovative portraitist if he was not under an uncomfortable obligation or pressed into uncongenial work by financial worries.

Born into a family of Danish extraction, and with an English mother who had a talent as a linguist, WALTER SICKERT's outlook was cosmopolitan and he spent much time working abroad. He began his career as an actor, but by 1881 he was attending the Slade School of Art for a brief spell before becoming Whistler's apprentice and etching assistant. From him Sickert absorbed a fascination for technique which always remained central to his art and to his teaching. Whistler also introduced him to Degas and this encouraged the young artist to pursue his interest in English music-halls as subject-matter. Sickert's love of the theatrical is well demonstrated in these works and a theatrical element occurs too in the infamous Camden Town Murder series of the 1900s.

This seedy area of north London yielded up many characters and scenes for Sickert's brush and led Osbert Sitwell to describe him as the only person who could "take the heavy Sunday boredom of the suburbs, and by some magic of hand and eye transmute it into beauty" (Sitwell, p. xx). For some, these pictures were too modern and too daring, though this endeared many young artists to Sickert and for a while he became the leader of an admiring circle. Equally at home with all levels of society Sickert could also paint the elegancies of Dieppe or Bath. Portraiture was an area where he painted both prince and pauper and in which he showed great originality though he was ever anxious not be enslaved by the genre. In the 1930s, due to one of many financial crises, he was forced to do some commissions and these portraits show the elderly artist experimenting energetically with a mixture of photography and newspaper cuttings as source material.

The vigour, originality and convincingness of Walter Sickert's portraits remind the viewer that while the best artists fuse their private selves into their artist's eye – discarding opinions, psychological intricacies, and emotional leanings – the unique flavour and energy of those selves does determine the features of their perceptions.

BIBLIOGRAPHY

ARTS COUNCIL *Sickert* (1997–8)

BARON, Wendy *Sickert* (Phaidon, 1973)

HART-DAVIS, Rupert *Hugh Walpole* (Macmillan, 1952)

FITZWILLIAM MUSEUM, CAMBRIDGE *Catalogue of Paintings: British School*, vol. III (1977)

SAVILE GALLERY, LONDON *Sickert Exhibition* (1928)

SHONE, Richard *Walter Sickert* (Phaidon, 1988)

SITWELL, Osbert (ed.) *Walter Richard Sickert A Free House!* (Macmillan, 1947)

SUTTON, Denys *Walter Sickert: a Biography* (Michael Joseph, 1976)

TATE GALLERY, Liverpool *W. R. Sickert: Paintings and Drawings 1890–1942* (1989–1990)

Stanley Spencer (1891–1959)

Self-Portrait with Patricia Preece, 1936

OIL ON CANVAS
61 × 91.2 cm (24 × 36 ins)
FITZWILLIAM MUSEUM, CAMBRIDGE

Stanley Spencer represents a milestone, but more aptly, perhaps, he could be described as a beacon on a lonely hill.

His *Self-Portrait with Patricia Preece* is a bold painting – bold both from the viewpoint of history in the 1930s, and from that of his own personal history. To consider its exhibition was audacious. Even in 1950 such subject-matter caused the erstwhile President of the Royal Academy Sir Alfred Munnings concern and he attempted to have Spencer prosecuted under the obscenity laws. These attitudes were anathema to the artist for he saw his work in quite other terms, as he wrote in his Daybook for 1938: "Existing laws and conventions interfere to a serious degree with my paintings . . . It is ghastly that my art should be made subject to what vulgarity happens to lay down in law and morality. Such values, applied to my pictures, are quite inadequate to elucidate their true meaning. I am not against anything I know of. I will examine a religious scale of values as carefully as a non-religious scale. If anything I am prejudiced to the religious side. But I am not going to have the religionist telling me what to worship. In all my sex experience I notice the same degree of emotion as a religious experience. But I feel lonely in finding myself the only worshipper when I am convinced the erotic side I am drawn to belongs to the very essence of religion. I feel that I am actually discovering a hoard of significant meanings to life, but am being hampered in my task. The intention of all my work is towards happiness and peace" (Pople, p. 381).

Since his student days at the Slade School of Art Stanley Spencer's work had caused puzzlement; there he had given unusual interpretations to the set-piece religious paintings he was required to produce. He began then, and continued throughout his career, to use the houses and gardens of Cookham, its river, and its twentieth-century inhabitants to express scenes of religious exuberance profoundly imbued with religious feeling and, in doing so, he gradually developed his theory about the analogy between God's creative energies and man's sexual love which caused conventional thinkers to baulk still further.

Although *Self-Portrait with Patricia Preece* has been regarded as daring it is fundamentally a painting about frustration and ultimate despair. Even without the biographical knowledge we have it would be hard to ignore the terrifying lack of communication manifested in the ostensibly intimate setting: it is a profoundly sad work. By the mid-1930s Spencer had become infatuated with Patricia Preece, yet wracked with indecision as to their future together. Between 1935 and 1937 she sat for a series of nude portraits which chart the artist's fluctuating feelings for her. On one level they represent a clearing of the mind for him, a tendency already apparent in the Burghclere Chapel murals of the previous decade. (There he depicted his experiences during the Great War

and in so doing felt he had resolved and absorbed them.)* However two months after painting the companion-piece to this picture – *The Leg of Mutton Nude*, a clear document for divorce – he married Patricia Preece, only to separate from her a year later in 1938. As his first wife Hilda had said: "uncertainty is another of his everlasting qualities" (Rothenstein, p. 57).

Stanley Spencer had met Patricia Preece (1894–1971) in Cookham in 1929. She was sharing a cottage there with Dorothy Hepworth, the two women having trained together at the Slade. Their friendship seemed somewhat ambiguous: Dorothy habitually dressed in masculine attire causing a newcomer to the village to remark on seeing them: "Fancy courting at their age!" (Rothenstein, p. 110). Patricia was sensitive to such observations and at one time accused Spencer of spreading rumours. It is significant that she often referred to Dorothy as her sister. Patricia's artistic talents were slight but she persuaded established painters such as members of the Bloomsbury Group to buy her work – which they did apparently out of pity – while she often exhibited Dorothy's work under her own name. Despite some feebleness Patricia clearly had the ability to manipulate people and, unfortunately, Spencer became one of her victims.

Spencer had never made a habit of painting gratuitous nudes although nudes occur in some of his visionary works and, prior to the series of Patricia Preece, he had drawn Hilda. Two nudes of Patricia dating from 1935 differ in mood from the two double nudes; the earlier in the Ferens Art Gallery, Hull, being quite conventional in pose, the latter rather more provocative but not at all pornographic for the whole concept of pornography was totally alien to Spencer's astonishingly innocent mind. The double nudes exude the despair he had come to feel about their relationship and this negates any suggestion of titillation. A drawing, dated 1942, underlines this innocence of intent. In it he has sketched the 'chapel' in which he wished to hang the nudes of himself and of his two wives. These pictures form part of the visual autobiography that was one of his most cherished plans – the Church House scheme – whereby a large body of his work would be permanently assembled in a building that looked like a church but was not one because, as he said: "there are a vast series of spiritual qualities of feeling that can only be found in a house and not in a church" (Royal Academy, p. 29) – notwithstanding his strong conviction of the links between the sacred and the profane.

By 1935 Spencer was mesmerised and increasingly tantalised by Patricia and the *Self-Portrait with Patricia Preece* begins to spell this out: the composition of their nude bodies sadly demonstrates a potentially disastrous relationship. Two pairs of eyes stare resolutely out of the picture frame though two bodies reside in close proximity within it, demonstrating a painful absence of that intellectual sympathy he always needed with his sitter.** Subtle shifts in tone isolate Patricia's alluring pink flesh from Spencer's pallid back, while her curvacious form and his tense pose betray, all too clearly, the true nature of their feelings for each other. That Spencer's face is sunburnt and his back white is no surprise for he painted landscapes out-of-doors all year round. Yet, as is so often the case with the artist's work, the natural and the metaphorical overlap here: his body has more

* Later he was to write: "The Burghclere memorial redeemed my experience from what it was; namely something alien to me. By this means I recover my lost self" (Robinson, p. 45).
** One of his later sitters, Marjorie Metz, observed how important it was "to be with him mentally" (Rothenstein, p. 134) while he painted; a disinterested sitter spelt disaster and he usually decided to discontinue the canvas. However, in spite of Patricia's attitude, perhaps it could be deduced that he chose to continue painting the double nudes as part of his pictorial autobiography.

contact with the sheet than with Patricia's body – all passion is forced to remain in his head. Their forms are pressed close to the picture plane making one think, rather ironically, of the manner in which the prostitutes of the red light district of Amsterdam disport themselves before the highly polished windows of their tiny living-rooms to catch custom; both approaches are extremely clinical. Furthermore Patricia's attitude to his art needs mention: because Spencer's landscapes and portraits were money-spinners she regarded the financially unviable areas of his work as a waste of time and obviously thought this picture futile, though she had posed, willingly, for the earlier nudes.

Enough documentary evidence exists to suggest that Patricia Preece decided to marry Stanley Spencer simply to advance her own financial comforts. Indeed some months before the marriage she had referred to him in public as "that dirty little Stanley Spencer" (Rothenstein, p. 102). It is perhaps further evidence of this astonishing man's sexual innocence that he expected Hilda, to whom he always remained close – although this closeness was often manifested only in epistolary form – to supply the missing link between him and his second wife: namely the sexual one. These wishes were not fully realised and this knowledge gives the painting an additional sense of joylessness.

STANLEY SPENCER took his "sense of wonder" (Pople, p. 3) from his father and a sense of the dramatic from his mother: both qualities are present in his art. Present too are other important experiences from early life: an interest in the Bible which the family habitually read, and an involvement with the place of his birth – Cookham – a small village on the river Thames where his grandfather had built a number of imposing villas, and where his father taught music to their middle-class inhabitants, travelling between one household and the next on a lady's bicycle reciting Ruskin. Spencer's education was suitably eccentric, directed by his sisters and supplemented by lively and wide-ranging discussions with his father and the older children, many of whom went on to professional careers. At the Slade, dubbed 'Cookham' because of his continuing need for this environment, the originality of his mind was quickly recognised. However, this originality was less easily understood.

After meritorious beginnings, war interrupted his career and he served as a medical orderly in Bristol and later in Macedonia. Menial work held no terrors for him "as long as I could recognise in it some sort of integral connection with the spiritual" (Pople, p. 106). Faint murmurings are evident here of his growing philosophy – the interaction of the sacred and the profane which would later lead to a specific link between the sexual and the spiritual.

In the 1920s Spencer's career resumed its acclaimed course, *Resurrection, Cookham* being purchased by the Tate Gallery in 1927, the year that he began the Sandham War Memorial Chapel at Burghclere. Meanwhile he had married a fellow-artist, Hilda Carline, in 1925. In 1932, on the completion of the Chapel, he was a well-established painter elected that year as an Associate of the Royal Academy. But soon after this the tide turned for him and marital problems, his divorce and re-marriage in 1937, ill-health and resulting financial difficulties, made the 1930s his crises years.

The 1940s was a decade that saw his personal and professional rehabilitation, beginning with a commission from the War Artists' Advisory Committee to paint a series of shipbuilding scenes at Port Glasgow. He continued to accept a certain number of portrait and landscape commissions in the ensuing years and to paint 'visionary' work. In

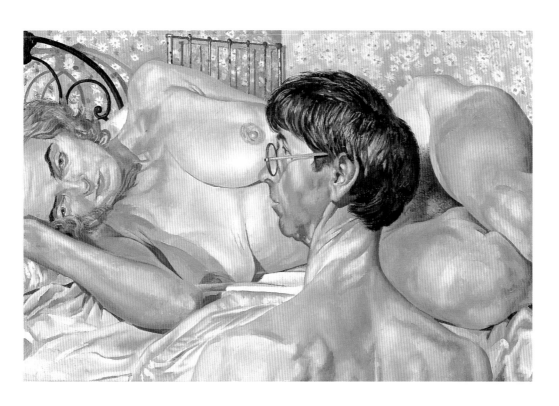

STANLEY SPENCER

Self-Portrait with Patricia Preece, 1936

1950 he was created a CBE and became a Royal Academician. In the same year his first wife, Hilda, died – he had helped, with devotion, to nurse her. In 1955 the Tate held a Retrospective while in 1959, the year of his death, he was knighted. Always a difficult character to understand, his nature was summed up by an old friend, Elizabeth Rothenstein, as one "which had in it something of the saint, something of the seer, majestic and formidable, but also something mean and quarrelsome, bitter and nasty, reminding one of a sparrow fighting in the dust."

Stanley Spencer is a unique example of how an artist of power, who is so totally absorbed in his own world of violent emotional and visionary experience, can function almost untouched by the human history evolving around him. With a few minor adjustments as to dress and furniture his work could have come into being in any age. Bosch could have painted – in hell – his nudes tortured by the ashes and inadequacies of sexual passion, or Fra Angelico his simplicities of beatitude. It seems almost an accident that the growing introspection, uncertainties, doubts and misgivings of the twentieth century resonated so exactly with what he felt, wanted to say, and the mode in which he was compelled to express this.

BIBLIOGRAPHY

NATIONAL TRUST *Stanley Spencer at Burghclere* (1991)
POPLE, Kenneth *Stanley Spencer* (Collins, 1991)
ROBINSON, Duncan *Stanley Spencer* (Phaidon, 1990, revised)
ROTHENSTEIN, John (ed.) *Stanley Spencer the Man: Correspondence and Reminiscences* (Elek, 1979)
ROYAL ACADEMY OF ART *Stanley Spencer, RA* (1980)
TATE GALLERY, LIVERPOOL *Stanley Spencer, a Sort of Heaven* (1992)

Dame Laura Knight (1877–1970)

Ruby Loftus Screwing a Breech-Ring, 1943

OIL ON CANVAS
86.4 × 111.6 cm (34 × 40 ins)
IMPERIAL WAR MUSEUM, LONDON

Though bold in her actions, and with many of the attributes of the 'new woman', Dame Laura Knight's own experience of life appears too uncertain ever to have vitalised her canvas. In many ways she was more of a reporter than a painter and one who had the dare-devilry, the stamina and the technical proficiency to paint subjects never before attempted by a woman artist. From her earliest years she had been an insistent child demanding, and expecting to receive, attention. She was a tomboy then and remained somewhat unfeminine always, but her compelling and gregarious temperament helped her, as a woman, to win friends in unlikely places. The slum children of Nottingham, the tough fisherfolk of Staithes in Yorkshire, circus performers, ballet dancers and, in the 1920s, on a visit to Baltimore the black people of that city. All enjoyed her company and loved her to paint them. Hours were spent socialising with them too, listening to the stories of their lives and to their jokes, for she was ever one for a bawdy tale as her friend Sir Alfred Munnings recalled. In Baltimore she was more daring than ever: whilst her husband Harold Knight worked on his portrait commissions for the Johns Hopkins Memorial Hospital she toured the city with two black women secretaries as her guides, attending gatherings and concerts, often the only white there and in danger of deportation if discovered.

During the Great War the art critic P. G. Konody suggested that Laura Knight should paint a picture for the Canadian War Records and she was sent to a Canadian army camp in Surrey for this purpose. She painted a boxing match, a highly unusual subject then for a woman to depict, but her ebulliant character won her the friendship of the camp's boxing instructor. Soon she was 'one of the lads' sitting sketching in the gym surrounded by an admiring audience who provided also a ready supply of cigarettes for her. With this and her work in the theatre and at the circus she became well-practised in researching a 'brief' and an obvious choice during the Second World War for further official work. The War Artists' Advisory Committee asked her to paint a young woman engineer, Ruby Loftus, screwing the breech-ring for a Bofors gun at the Royal Ordnance Factory in Monmouthshire. Ruby had learned this skill in record time and, in true chauvinist manner, the authorities wanted to use her as a sort of industrial 'pin-up'.

This picture is unique in its content. In 1943 it would still have been more usual to see a painting of a woman at a sewing-machine. However, Dame Laura's presentation is totally academic, really more of an advertisement than an imaginative composition. That both factual detail, essential to this commission, and powerful imagination are possible in the same composition is evident when comparing this work with Joseph Wright of Derby's approach to the Industrial Revolution in the eighteenth century: information coupled with wonder. We should be wondering at Ruby Loftus's skill and be curious as

DAME LAURA KNIGHT

Ruby Loftus Screwing a Breech-Ring, 1943

to what motivated a twenty-one year old girl to learn in two years what took the average man at the Royal Ordnance Factory eight. Instead, the dazzling array of machinery upon which she concentrates remains of interest only to the experts; Ruby Loftus could just as well be baking cakes! The portrayal is bland and lifeless, the personality generalised.

It is interesting also to compare this picture with Maggi Hambling's portrait of Professor Hodgkin: clearly Hambling is no more of a scientist than Knight is an engineer but her empathy with the Professor, coupled with an instinctive knowledge of how to make the composition work, has produced a portrait that is light-years beyond Laura Knight's neat piece of propaganda (see the discussion on p. 79). Some years previously the *Times Literary Supplement* had remarked upon the artist's stylistic tendencies: "Dame Laura aims at forcible realisation, without much care for composition or curiosity for what lies behind the facts . . . All her struggles have been external – with the technical side of her art and with material circumstances . . . This leaves the impression that Dame Laura Knight has never suffered the self-mistrust and misgivings which afflict many if not most artists . . . The struggle appears always to have been outwardly directed and there is no indication anywhere of an inner conflict" (Dunbar, p. 148).

But why did she live so much on the surface? A childhood during which, despite great happiness, she knew sudden poverty and the deaths of those near to her, would suggest early experiences of pain. But pain can be debilitating. It is possible that in her determination to cope with life she learned too thoroughly to suppress her feelings, so that, despite her energetic involvement with people and her curiosity about their occupations, she never risked – or was no longer able to risk – that empathy essential to the painting of a great portrait. Where the man, or woman, refuses to suffer, the artist cannot create.

BIBLIOGRAPHY

DUNBAR, Janet *Laura Knight* (Collins, 1975)
FOX, Caroline *Dame Laura Knight* (Phaidon, 1988)
KNIGHT, Dame Laura *Oil Paint and Grease Paint* (Ivor Nicholson & Watson, 1937 edition)
 The Magic of Line (William Kimber, 1965)

Graham Sutherland (1903–1980)

Sir Winston Churchill, 1954

OIL ON CANVAS
147 × 121.9 cm (58 × 48 ins)
DESTROYED

If the artists already discussed are milestones, Graham Sutherland is where we arrive: those who have gone before direct us to *his* approach to portraiture. Only in Sutherland's canvases do we find a full awareness of what has happened to the human consciousness being translated into paint: and by perhaps the greatest British artist of the century. Thenceforward other painters become able to express these changes which some had felt before, though none with precision.

On 30 November 1954 the Prime Minister, Sir Winston Churchill (1874–1965), was presented with a portrait of himself painted by Graham Sutherland. Accepting it as a tribute from both Houses of Parliament, to mark his eightieth birthday, he commented with political deftness that it was "a remarkable example of modern art. It certainly combines force and candour" (Soames, p. 633). The commission had been arranged by a committee representing all the political parties and Sir Winston was pleased with their choice of Sutherland for he knew him to be much admired by his friend Lord Beaverbrook, a recent sitter to the artist. But, from the moment that it was unveiled, the picture caused controversy. The Premier's somewhat ambiguous reception of it in Westminster Hall was translated by some into disapproval. *The Illustrated London News* referred to it as "powerful, but unflattering" (*ILN*, 4 December, 1954, p. 991). Lord Hailsham called it "disgusting. It is ill-mannered. It is terrible" (*The Times*, 12 January, 1978). However, most art critics admired it though further first-hand consideration of the portrait became impossible because it was never again seen in public. Twenty-four years later, shortly after Lady Churchill's death it was learned that she had ordered its destruction. She felt it to be too shocking an exposure of Sir Winston's failing powers. The shock is multiplied: it is difficult to accept that so remarkable a painting has been wilfully destroyed.

The commission, and the effect that it had on its audience in 1954, marks a watershed in the history of British portrait painting. Just how profound a watershed in terms of art I shall consider later. The story – culminating in the painting – is of an aristocratic statesman, born during the reign of Queen Victoria, a man possessing a mixture of far-sighted vision and prosaic tastes, being painted by an artist of the greatest integrity, a man who saw the world from a highly individual point of view.

The Churchills had been married for forty-six years when Sir Winston's eightieth birthday celebrations occurred. Clementine Churchill was eleven years her husband's junior and throughout her married life she had always been accustomed to his holding high offices of state. Indeed by 1908, when they married, Churchill was considered sufficiently distinguished to be included among Mme Tussaud's collection of waxworks. Not only had he taken part in the cavalry charge at Omdurman, been captured by the

Boers in South Africa, crossed the floor of the House of Commons to join the Liberals over tariff reform, but as President of the Board of Trade he had a seat in Asquith's Cabinet. So, from the first, his wife was surrounded by politicians and statesmen and quite as quickly she realised the need to enhance and protect her husband's political image. This attitude was to run like a leitmotif through their life together and it played its part in their reception of the Sutherland portrait.

Up to a point, the Churchills had mixed in artistic circles. As a young girl living in Dieppe, Clementine and her family had known Walter Sickert well. In 1915, on leave from the trenches, Winston Churchill had taken painting lessons from Sir John Lavery and thereafter numbered art among his hobbies and relaxations. Yet the couple had a rather circumscribed approach to art – perhaps to be expected from Churchill's association with Lavery – becoming uncomfortable if pictures in any genre did not conform to a rigidly traditional pattern. Mr Graham Sutherland may have been "a 'wow'" of a person to Lady Churchill when she first met him in 1954, but his landscapes seemed savage and cruel to her eyes. As yet she had no opinion on the few portraits he had made though an earlier portrait of Sir Winston, painted by Orpen immediately after the Dardanelles fiasco of 1915, earned tart criticism from her because she thought it made him look a 'finished' man.

As a character Lady Churchill could be dignified and reserved, spontaneous and spirited. By some she has been seen as loyally protecting her husband's interests and by others as exhibiting bad judgement and interference. Her life was marked by impetuous actions, for example her childhood tidying away into the rubbish-bin of the herring Sickert had been planning to paint; the dramatic rescuing of Churchill from death in front of a train during the 1909 election campaign; and, finally, the destruction of the Sutherland portrait.

From its beginning Sir Winston Churchill's career was a spectacular one and his early journalistic pieces and books concerning his 'adventures' in Africa, India and Cuba encouraged the rapid growth of his legendary status. Coupled with this was a boundless energy and a quickness to espouse large causes which were usually concerned with Britain's security and position in the world. His long political experience and penetrating vision made him sharply alert to the threats of Nazism and later Communism. He sensed that the rest of the country were not sufficiently aware of these dangers and urgently desired to hold onto office until he had constructed at least some basic safeguards. Churchill's influencing of these events began in earnest in 1940 when he was made Prime Minister at the age of sixty-six. At that time the Cabinet felt it prudent to appoint Lord Moran to be his official doctor. Soon Churchill's health began to cause increasing anxiety and in 1943, Lord Moran noted in his diary that the Premier's "contempt for commonsense" together with his heavy workload – "he has been doing the work of three men" (Moran, p. 99) – were contributory factors. Bouts of pneumonia, a heart attack and strokes occurred during the remainder of his active career but Churchill's constitution was fundamentally tough and, not infrequently, he surprised his doctors and family with his powers of recovery.

After 1945 the unanimity of purpose that had largely existed at Westminster during the war ceased, and the daily criticisms of politicians peculiar to a democracy made Churchill's health of especial interest to all concerned. It became of acute interest when he resumed the Premiership in 1951 and reached a pitch of excitement in 1953–4 – the

period during which the Sutherland portrait was being contemplated. In February 1954 *Punch* published a cruel cartoon of Sir Winston looking lifeless and hollow together with an editorial by Malcolm Muggeridge – a long-standing admirer – which said, effectively, that he should retire. Such alarming and widespread publicity was soon reflected in a left-wing press campaign during which the *Daily Mirror* called him "the Giant in Decay" (Moran, p. 531). It was now April, but still Churchill vacillated over his future, desperate to further his policy "Not perhaps (of) world peace, but world easement" (Moran, pp. 409–10) arguing further that his colleagues "need my flair" (Moran, p. 593). In a diary entry dated 30 November 1954, Lord Moran ruminated on his patient's quite remarkable powers of survival over the fifteen years he had treated him. He had had a heart attack in 1941, two strokes, three attacks of pneumonia, two operations, and senile pruritis (a skin disease), while for ten years he had never slept without sedatives . . . and then there were his heavy meals, drink and cigars. Much of this information had been carefully hidden from the public's knowledge: but how would the Sutherland portrait be received and interpreted?

Graham Sutherland began making preparatory sketches for the picture on 26 August 1954 and continued with this work for a month. During their sittings the Prime Minister talked endlessly of his political preoccupations, repeatedly telling Sutherland "But I am a rock" (Tate, p. 138). Sutherland, remembering Sir Winston's war-time efforts when Britain fought alone, saw him in terms of those huge boulders weathered by the centuries that often mark so significantly his landscapes. For a man much affected by symbolism and metaphor the "rock" analogy was to Sutherland an obvious one; while, in literal terms, Churchill's bulky form added credence to the conception. Before his eyes the artist was, of course, witnessing his sitter's fight with old age, and, in deciding to paint him seated he has minimised this struggle. Though Churchill's lip appears to oscillate, his eyes contradict any loss of control: they emit sharpness and resolution still.

Sutherland was an 'occasional' portraitist and so largely indifferent to public opinion. His aim was to paint a true picture of his sitter, in his terms, and the noting down of the intimations of mortality were all part of that honesty. It had never occurred to him when painting objects in the landscape that a broken root had lost its life and potency; on the contrary it usually assumed greater potency. As he was to say years later, "I want neither to flatter nor denigrate" (NPG, p. 28). Here, in the Churchill portrait, there are parallels with his Lear-like tree-trunks: the flesh may sag, the body may be slumped, but there remains an enormous willpower determined never to be eroded by the wash of events.

Photographic reproductions give a clear indication of Sutherland's intentions for the commission but the loss of the original painting has meant that one cannot respond with any precision to it: the true 'feel' of the portrait is lost. Even so, it can be considered as a 'bridge' between past and present attitudes to public portraiture. Today we are used to the idea of our privacy being invaded, but such an intrusion was still unusual in the Britain of the 1950s, particularly so when the sitter was the Prime Minister. Sir Winston Churchill may have been democratically elected to Parliament but he was an old-fashioned aristocrat, radical only when it came to power-politics, not a man who mixed with the people. Perhaps this is a little surprising considering that his American-born mother, Jennie Jerome, on whom he relied much for advise during his early career, warmly embraced the new mixed society of the 1920s and delighted in the

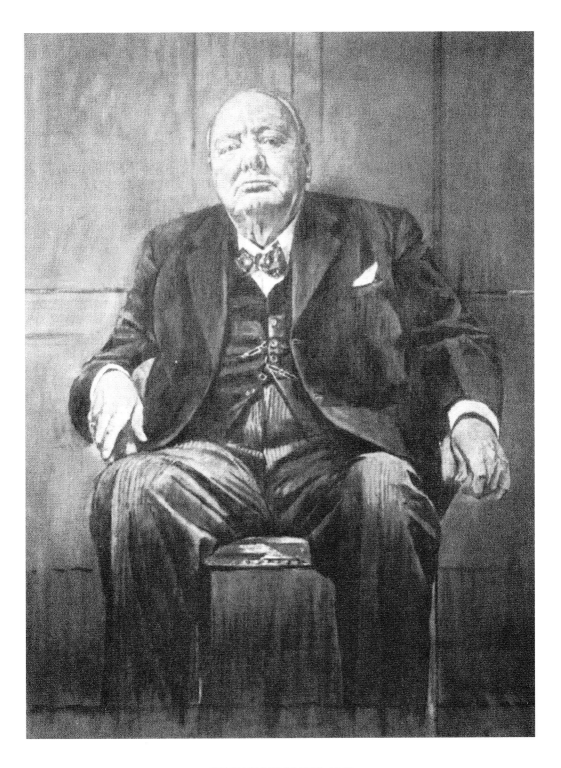

GRAHAM SUTHERLAND

Sir Winston Churchill, 1954

modernity of writers, musicians and artists such as Conrad, Bennett, Ravel, Stravinsky and Picasso. But, despite her catholic approval Churchill had created a legend about himself at an early age. As he told the sculptor Oscar Nemon, "It is not your business how I look naked" (*The Times*, 13 January 1978). That he was frightened by, as well as admiring of, the portrait is almost certain. An article in *The Times* in January 1978 quotes him as having said that "it makes me look half-witted, which I ain't", and, coupled with his accusations of lèse majesté would have been anxiety over how his detractors were reacting to the picture. His doubts and fears were echoed by his wife: in 1945 Lady Churchill had wished him to retire so as to keep his image untarnished. By 1954 his daily vacillations over whether to resign or not, together with almost a year of quite severe bouts of illness, had left her exhausted and short-tempered. Initially she had admired the picture but its powerful ambiguity must have worked to its detriment, no doubt transporting her, to quote the sculptor David McFall, "into a screaming dervish" (Hough, p. 533).

Following Clementine Churchill's death in 1977, the news of the portrait's fate broke and, in a leader in January 1978, the *Daily Telegraph* commented: "It is possible to pity, even understand, Lady Churchill's act, but not to excuse it." Interestingly, Graham Sutherland's first-ever portrait, that of Somerset Maugham (1949) – which the sitter delighted in – shocked and outraged the public when it was exhibited at the Tate Gallery in 1951. But along with such emotions went an awareness that the accepted conventions for portraiture were silently being set aside: by 1954 a watershed had been reached. Now it is indeed no longer the public persona for which the artist seeks, but the naked man.

GRAHAM SUTHERLAND developed an interest in nature and geology during a lonely childhood and because of it began the practise of regular drawing from nature which became the mainstay of his art preventing, as he explained, its descent into the merely decorative and vacuous.

After a brief engineering apprenticeship he studied at Goldsmith's College, concentrating there on printmaking techniques. At the age of twenty-two he was elected an Associate of the Royal Society of Painter-Etchers and Engravers where he exhibited regularly until his increasingly modern style met with their disapproval. But soon the 1929 Wall Street Crash destroyed the American-led print market and, like other printmakers, Sutherland was forced to turn to teaching and commercial work in order to earn a living. This also made him decide to master the techniques of oil painting.

In 1934 he was introduced to the Pembrokeshire landscape, an abiding source of inspiration for him. In his representations of it he eschewed a strictly literal approach, instead seeking in its forms anthropomorphic metaphors: dead and rotting branches resembled figurative forms; tree and plant life, buffeted by the elements, showed a human tenacity; and the brooding Pembrokeshire mountains carried in them echoes of man's presence in the universe. But never was anything made specific, for, as he commented: "Coleridge said that poetry gives most pleasure when generally and not perfectly understood . . . So in painting it might be argued that its very obscurity preserves a magical and mysterious purpose" (Hayes, p. 17).

During 1944 Dean Walter Hussey obtained his agreement to paint a 'Crucifixion' for St. Mary's Church, Northampton. Sutherland, a devout Roman Catholic, was fascinated by the "duality" of Christ's Passion – its tragedy and hope – so this rather traditional commission became a challenge for him. He took up a further challenge in

1949 – a portrait commission to paint Somerset Maugham. If, in his landscapes, he was led towards a metaphorical approach, with the human face he rejected abstraction for, as he explained, people's faces are "obscure enough" without the artist putting further "distance between the subject and the spectator" (Hayes, p. 32). His transmogrified trees and boulders were an attempt "to announce something that nobody looks at. But as far as people ever really look at anything, they do look at faces: and as the human head is interesting enough to me also I try to understand its essence by more direct methods" (Hayes, p. 32).

Thereafter followed further portrait commissions, though Sutherland remained fairly choosy about his sitters. His large tapestry for Coventry Cathedral absorbed most of his time, and creative energies, in the 1950s and was completed in 1962. It is noticeable that, latterly, this led to less interesting landscape work, his pictures of natural life tending to be decorative and no longer an emblem of struggle and suffering. However, with his return to Pembrokeshire to paint in 1969 came a rejuvenation of his imaginative powers: the romance and mystery, so much a part of his style, returned.

Graham Sutherland is perhaps an exemplar of the true artist: wholly committed to the truth of what he sees, and seeing with an eye uncluttered by pre-conceptions, prejudice, or any anxious sideways glance towards self-exposure or his pocket book. He was conditioned by his times only in so far as he was understanding of what those times expected, and compassionate in this awareness. Perhaps he was fortunate in that the bedrock of this awareness was a calm certainty of belief in the significance of human experience, and possibly this 'fortunateness' – this certainty – is the element without which greatness cannot realise itself.

BIBLIOGRAPHY

CHISHOLM, Anne and
DAVIE, Michael *Beaverbrook: a Life* (Hutchinson, 1992)
DAILY TELEGRAPH 13 January 1978
HAYES, John *Graham Sutherland* (Phaidon, 1980)
HOUGH, Richard *Winston and Clementine the Triumph of the Churchills* (Bantam, 1990)
ILLUSTRATED LONDON NEWS 4 December 1954, p. 991
LESLIE, Anita *Jennie: the Mother of Winston Churchill* (George Mann, 1992)
MORAN, Charles *Winston Churchill: the Struggle for Survival 1940–1965* (Constable, 1966)
NATIONAL PORTRAIT GALLERY *Portraits of Graham Sutherland* (John Hayes, 1977)
SOAMES, Mary *Clementine Churchill* (1979)
TATE GALLERY *Graham Sutherland* (Ronald Alley, 1982)
THE TIMES 12 and 13 January 1978

Frank Auerbach (b. 1931)

Head of E.O.W. III, 1963–4

OIL ON BOARD
68.6 × 57.7 cm (27 × 22³/₄ ins)
PRIVATE COLLECTION

Following the watershed created in British portraiture by Graham Sutherland in the 1950s, the breakthrough to the modern consciousness becomes apparent to everyone in Frank Auerbach's work. In their open self-expression and naked self-preoccupation his faces do not belong to the 'family' of portraits seen so far for, from the earliest days of his careers Auerbach has taken an approach to the art of portrait painting that is outstandingly different from all other. Not only are the obvious 'clues' as to the sitter's status absent in his work but straightforward information about sex, looks and character are subdued. However, Auerbach always paints from the life using a small group of family and friends as his models, painting their pictures over and over again. For him the posed human figure is the ultimate test of an artist's skill and as a corollary to this his models are required to sit for many hours and for many days.

Frank Auerbach's first memories are of the dawning threat of Nazism and the increasing anxiety it caused his Jewish mother and father. At the age of eight he was evacuated from Berlin to England, never again to see his parents who perished in the concentration camps. This experience marked him for life, breeding in him an overwhelming need for security and routine: a need to live and work in the same place, mix with the same people, and, ultimately, to paint the same models.

In 1948 the artist met Stella West (E.O.W.) who was to remain his most constant model for the next two decades. She was an impoverished widow aged thirty-two who enjoyed amateur dramatics and belonged to the same theatre group as Auerbach. She had no knowledge of art but struck up a friendship with the seventeen-year-old painter and agreed to pose for him. Soon they became lovers and her home and young family a secure haven where the artist could grow in confidence and maturity.

Years later E.O.W. recalled the early sittings. They usually took place three evenings a week and were long sessions with brief rest periods in the middle. Auerbach was demanding of her, requiring stillness and silence as he painted, and only the smell of the roasting lamb, which they would eat afterwards, brought comfort to her senses. Looking at the portraits of E.O.W. it is remarkable how inaccessible they are and how little they tell us about her. Yet something was being communicated between artist and model which brings an entirely new point of view to the art of portrait painting. At times E.O.W. was almost cowered by Auerbach's mood during their sittings and on such occasions she sometimes cried: "sometimes Frank painted me with tears streaming down my face because he seemed so cruel and so far removed from me, and I'd think: well, what am I? I'm nothing, nothing. But I was something . . . The first inkling I got of this was when I was sitting and thinking about my childhood, which wasn't easy. Suddenly Frank said to me, '*Stop thinking that! Stop bloody thinking that!*' And I realised there was some telepathy,

FRANK AUERBACH

Head of E.O.W. III, 1963–4

some actual communication between us when he was painting me" (Hughes, p. 134). Of course, the telepathic empathy is not available to the spectator; indeed nothing is clear or specific, all is the merest of hints, but these hints spring from Auerbach's instinctive knowledge of his sitter, of which the telepathy is an expression. The hints are authentic, and his command of his craft is such that he can give form to his intuition while boldly eliminating the obvious. The spectator, responding to the authenticity, sees E.O.W. as if she is looming into view like a figure walking towards us at dusk.

Certainly the results of the communication between E.O.W. and Auerbach are shadowy to the conventional eye. The *Head of E.O.W. III*, painted between 1963 and 1964, is particularly difficult to 'read'. At first the face seems lost in the thick, swirling mass of bright colour. Then sense begins to be made of the features and of her mood. Just as the artist accumulated knowledge and information about Stella West over a number of years, so the viewer, referring back to the earlier paintings of her, can begin to recognise her characteristics: the thin-lipped mouth and the oval, high cheek-boned skull distinguish her and, in this painting, they and her mournful mood are evident underneath the lively paint. Her eyes, nose and mouth are black, with some interference from other colours; her head is clearly set on her shoulders, and the segmental strokes of red enclosed by them suggest a garment with a collar or, perhaps, a scarf draped around them. It is almost as if there are two worlds superimposed upon each other in this portrait: the extravagant, noisy 'high-street' world demonstrated by the colourful lines of the clothing and then, within this jazzy exterior, one feels E.O.W.'s stillness. As Auerbach's first dealer Helen Lessore had spotted in 1956, stillness is the key to his work, together with introspection and naturalness: his intentions are not to produce expressionist, rhetorical pictures. It may be a paradox that all the energy and quantity of his paintwork lead to an inward quiet – or more aptly perhaps a resignation within each picture – and it may be a paradox that he should value his sitters so much, and even name them, and yet be so reticent about their personalities, but this leads back to the artist's roots in Germany, and to his need to search always for the familiar, and to extract it, if needs be, from the psychological gloom.

FRANK AUERBACH was born in Berlin in 1931 and by chance has come to spend the remainder of his life in England, referring to himself as "a born-again Englishman" (Hughes, p. 83). In 1939 he was offered a place at a school in England run by a German Jewish Quaker and his parents thankfully agreed to his evacuation from Hitler's Germany. In 1948 he was accepted as a student at St. Martin's School of Art but with two terms to fill before his course began he enrolled at the Borough Polytechnic. There he was taught by David Bomberg and was profoundly affected by Bomberg's intellectual probing, together with his habit of treating his students as equals. The young man's attention was also captured by Bomberg's aesthetic of 'the spirit in the mass' whereby he attempted to condense and strengthen the visual rhythms that lie below the surface of what we actually see. Such challenging allowed Auerbach to dare to be his own man and to eschew current artistic trends, while beneath his thick layers of paint lie buried traces of his teacher's aesthetic.

Early critics of Auerbach's work looked askance at the thickness of his paint, wondering whether it made a picture or a sculpture. The artist was exceedingly surprised by this reaction, commenting: "I don't know how they can talk about thickness, really. Is

blue better than red, thick better than thin? – no. But the sense of corporeal reality, that's what matters. English twentieth-century painting tends to be thin, linear and illustrative. I wanted something different; I wanted to make a painting that, when you saw it, would be like touching something in the dark" (Hughes, p. 86).

Frank Auerbach's range of subject matter is limited: portraits of a few familiars, landscapes of a small area of London – Camden Town and Primrose Hill – and little else. Within these, necessarily, secure confines he has explored ceaselessly. As has been suggested in the discussion of the *Head of E.O.W. III*, with the great intimacy in his subject matter has come an abbreviation in presentation. The spectator needs to get onto Auerbach's wavelength in order to understand his transitions from the objective to the subjective. Yet that subjectivity never errs from the figurative which means that when it comes to considering Auerbach's portraiture one is left regarding images that are compellingly different from the usual though, like his contemporaries, he is aware of, and expresses, the vulnerability of the individuals he paints.

BIBLIOGRAPHY

ARTS COUNCIL *Frank Auerbach* (May–July, 1978)
BRITISH COUNCIL *Frank Auerbach Paintings and Drawings, 1977–1985* (British Pavilion XLII Venice Biennale, June–September, 1986)
HUGHES, Robert *Frank Auerbach* (Thames & Hudson, 1992)
MARLBOROUGH GALERIE, Zurich *Frank Auerbach: Paintings and Drawings, 1954–1976* (1976)

John Bellany (b. 1942)

Self-Portrait with Jonathan, 1967

OIL ON BOARD
122 × 91.5 cm (48 × 36 ins)
GLASGOW ART GALLERY AND MUSEUM

The painting of portraits is not something that has occupied too much of John Bellany's time although a good deal of his work is autobiographical in content. Only in the 1980s, when he had come to the universal attention of the critics, did the National Portrait Gallery commission him to paint the cricketer, Ian Botham. This picture, and a small body of images of his family, fellow-artists, and museum curators – all painted during 1985 – were then exhibited at the Gallery. Though these portraits are varyingly interesting they show a falling-off in intensity due perhaps to his facility as a painter which had tempted him to toss off rather too many of them in one year. His self-portraits and family likenesses of the 1960s and early 1970s are, by comparison, much more redolent with significance and with his preoccupations as an artist than much of the later work barring, arguably, a body of portraits done during the period of his liver transplant operation and convalescence in 1988. John Bellany's portraits, good and bad, do, however, reflect the uneasy direction in which our century has progressed since the Second World War.

Self-Portrait with Jonathan was completed in 1967 when Bellany was twenty-five and a graduate student at the Royal College of Art. His was a precocious talent nurtured at Edinburgh College of Art (still noted for its highly disciplined degree course) and amongst such contemporaries as Alan Bold the poet, and the artist Sandy Moffat. Bellany's Fine Art studies there were balanced by an introduction to the poet and intellectual Hugh MacDiarmid, and to a circle of people keen to elevate awareness of Scottish culture. It is no wonder that when Professor Carel Weight visited the College as an external assessor he was struck by Bellany and felt impelled to invite him to continue his post-graduate studies in London. Weight remembered him then as "a larger-than-life character, a young man of immense promise," and as "painting extraordinary, sincere statements" (McEwen, p. 51). Weight's remarks are very relevant when considering the 1967 *Self-Portrait* for not only has Bellany gone against the artistic trends of the decade by eschewing aesthetic scribbles in favour of realism – and an out-and-out realism poles apart from David Hockney's witty allusions to it – but he has painted a portrait of high seriousness setting out his ambitions as an artist. In the picture he is seated on a stool with Jonathan on his knee. Behind them, enclosing their portraits and filling the remainder of the composition, is another painting. On either side of it stand two fishermen prefiguring the life of the man and boy in the portrait. The fishermen hail from Eyemouth in Scotland, the home of John Bellany's maternal grandparents and the scene of his early childhood where, in the harbour, he first began to draw. His 'portraits' then were of boats.

All the characters in the *Self-Portrait* wear grim expressions; Jonathan, like his father, being instinctively aware of the perils of the sea. Bellany, as narrator, describes the

sufferings that they do, or will, experience rather than identifying himself as in a normal portrait. In this so-called *Self-Portrait*, as in all the other self-portraits or genre pictures in which he appears, he wears a persona. He seems to want to hold the spectator deliberately at arm's length, wishing to share only the universality of his sufferings – the fears, the sorrows, the premonitions. The details of his life are omitted from these pictures for they would cloud the issues and introduce, unnecessarily, the mundane.

The pair of fishermen in the background frame the artist and his son drawing attention to the Bellanys' stern bulk. The earth-coloured tones of their long working aprons link the eye to the paint-brush in the hand of their creator. The stiff, angular shapes of all the characters act as symbols for their struggles with the sea. There is, too, a suggestion of discipline in their postures emanating as we know from Bellany's childhood during which the Calvinist religion, still practised in the East of Scotland, was part of his daily life. As his biographer John McEwen has written: "what other Western artist in the second half of the twentieth century was brought up in a society that could well be described as mediaeval?" (McEwen, p. 15) – or, one might even say, atavistic.

For most of the 1960s John Bellany pursued his undergraduate and post-graduate studies, though almost from the beginning his art was unusual and strikingly mature. Not only was the influence of his religious upbringing strong, but he was still steeped in the superstitious lores of the fishermen. In such a society death was a subject near the front of most minds and it hovers suggestively over his pictures or is more specifically alluded to as in *The Bereaved* (1968), a picture of his grandmother painted shortly after her husband's death. In comparison to *Self-Portrait with Jonathan*, in which the characters anticipate their future, this is the face of an old woman which has a completeness to it: she has known much but can now rest easy with her faith as her comfort. Her portrait, like the *Self-Portrait with Jonathan*, is not a palpable likeness. It certainly bears some resemblance to contemporary photographs of her, but her grandson was not interested in achieving more than an approximation because he wished to concentrate only on those essential features opening directly upon the universal human condition.

During 1967 John Bellany was given the opportunity to visit Buchenwald. His realisation of the horror created in this concentration camp turned his attention away from the consideration of suffering as a fairly normal part of human existence towards the nature of evil and, ultimately, the bestiality latent in mankind. In the paintings inspired by this visit he seems to see evil as taking away from man the ability to confront and endure his fate. In a series of 'crucifixion' scenes there is no indication of a resurrection; Christianity is no longer a support. Whereas in *Self-Portrait with Jonathan* the fishermen's arms appear severed – though they in fact express a weird control – in the pictures painted upon his return from Buchenwald people's limbs are broken or cut away. In them every element of the cruelty of the crucifixion is taken to its ultimate conclusion while in *Self-Portrait with Jonathan* the fishermen stand rock-like, unshakeable, like lighthouses against the storm.

But, following this astonishing perception of the nature of evil, suddenly the vision becomes blurred. At this period of the early 1970s Bellany changed his method of working from painting on hardboard, which responds best to slow, careful handling, to using canvas. This accelerated his rate of production, creating in him a sense of urgency perhaps spurred on by personal unhappiness. By 1972 his work had changed markedly and he seems in it disconnected from his roots. His characters no longer suffer, they

merely demonstrate the horror of suffering. The titles of his paintings *Sad Self-Portrait*, *The Gambler*, *Walking the Plank*, *The Drinker*, indicate most clearly his worried state of mind.

Then, in 1985, came the Botham portrait commission. When the picture was exhibited by The National Portrait Gallery, together with several other portraits, it opened a national discussion on the nature of Bellany's talent. John Spurling's review of the show perhaps describes most clearly the artist's achievements in portraiture at that time: "The portraits of the artists and curators – I can't speak for the sportsmen or the family – are neither likenesses nor caricatures, but crude approximations to likenesses, as if they had been done from indistinct memories in a tearing hurry; and all the paintings – sportsmen, family, artists and curators alike – share a complete lack of conviction about the presence of another human being. In fact these dashed-off outlines of figures jazzed up with brightness and splash are nothing more than instant poster-art and, if it were not for the romantic susceptibility of curators to the notion of white-hot creativity, they would surely have no place in The National Portrait Gallery" (*New Statesman*).

That Botham and the other sitters are only "crude approximations to likenesses" is not an overwhelming problem in a century when the camera and film reign supreme. But that these portraits seem to be no more than "instant poster-art" is of more concern. John Bellany has not given himself the right amount of time to dwell on these sitters or on the nature of his response to many of them – they remain shadows. That Botham is thought of as an icon seems to indicate a complicity between John Bellany and his admirers to devalue the high seriousness of symbols. And just to take the depiction of Botham's shoulders: their size is awkward and made even more so when we see the indiscriminate repetition of this mannerism in later portraits. In comparison, the thin shoulders of the fishermen in the 1960s paintings are integral to the meaning of those compositions.

Suddenly, in 1988, there is a resurgence of power in the self-portraits; it occurred during Bellany's stay in hospital for his liver transplant operation. By now the artist's personal problems were more resolved and he had to struggle instead for his life, a life for which he now cared. It is almost as if he has come full circle to reconsider the awareness of death and suffering which had preoccupied him when painting himself and the fishing life of his home town in the 1960s. But the difference lies in the optimism with which he gazes out of the pictures.

Portraiture is not, and never has been, a central part of John Bellany's oeuvre and it should not be judged as such. At their best his portraits give us an insight into his view of the human condition and of where he stands in relation to it.

JOHN BELLANY was born into the fishing community of Port Seton, a part of Scotland which took its terms of reference from the Calvinist religion and the rigours of a seafaring existence. Its communications with the larger world were little developed until after the Second World War. During his student days (1960–1968) Bellany worked hard and played hard, developing a liking for the "amber nectar" (McEwen, p. 33) which led, eventually, to severe liver failure and a transplant. His childhood experience of the sea, his seminal visit to Buchenwald in 1967, the separation and divorce from his first wife, Helen (1974), and the illness and death of his second wife, Juliet (1985), consolidated the underlying concerns in his art. Though his early work is more intense and challenging he has created a significant body of art since. His friend Sandy Moffat explains that "Bellany's particular genius has been in transforming the raw subject matter of his life by means of a

JOHN BELLANY

Self-Portrait with Jonathan, 1967

highly individual blend of symbol and allegory, into a painting style of visionary complexity, supremely concerned with life's ultimate mysteries. At a time when most contemporary artists appear to delight in operating on the edge of insignificance, Bellany's painterly fluency and grandeur communicate a sense of purpose and meaningful direction, comparable only with the very greatest artists of our century" (Kelvingrove, p. 6). It is a pity that in these later works the "sense of purpose and meaningful direction" appear too deliberate: they are thought, but no longer felt.

BIBLIOGRAPHY

ART GALLERY & MUSEUM KELVINGROVE, GLASGOW *A Long Night's Journey into Day* (1992)
FITWILLIAM MUSEUM, CAMBRIDGE *John Bellany in Cambridge* (1991)
McEWEN, JOHN *John Bellany* (Mainstream Publishing, 1994)
NATIONAL PORTRAIT GALLERY, LONDON *John Bellany* (1986)
NEW STATESMAN John Spurling, 14 March 1986
SCOTTISH NATIONAL GALLERY OF MODERN ART, EDINBURGH *John Bellany's Paintings, Watercolours and Drawings (1964–1986)*, (1986)

Francis Bacon (1909–1992)

Self-Portrait, 1973

OIL ON CANVAS
35.5 × 30.5 cm (14 × 12 ins)
PRIVATE COLLECTION

In his autobiographical narrative painting and in his portraiture John Bellany covers a range of preoccupations – family roots, the needs of the individual, the perils of disconnectedness – which have become central issues to us all. Francis Bacon's approach to the human condition, as expressed through his portraiture, is the opposite: he is a milestone to cynicism and despair. He was, too, the antithesis of the society portraitist; he abhorred any hint of a literal approach to his subject and refused to allow sittings. Instead he relied on his cumulative observations and on photography, although the photograph was only used as a starting point and not as a working drawing. He almost never accepted portrait commissions, preferring to paint his friends having studiously "watched their contours, and watched the way they behaved" (Sylvester, p. 74) knowing that they understood his concern with facts, "or what used to be called truth", (Tate, p. 10) and thus would not be offended by his deeply sincere but most unconventional approach to the genre. Using the same principles, but with the aid of a mirror, Bacon often painted himself. His *Self-Portrait* of 1973 is not like him in any ordinary sense of the word; it is, however, characteristic of the man, something which becomes evident when it, or any other of his many self portraits, is compared with a photograph of him. The tilt of the head, the straying lock of hair, the pouches under the eyes, the podgy jowl, all hint at the identity of the sitter despite the apparent violence caused to the face. It seems as if someone has squeezed Bacon's cheeks between fingers and thumb and thereby distorted his jaw, mouth and eyes. Yet this initial impression is followed by a sense of quiet energy. His right eye shows something of Bacon the reflective man while what can be seen of the mouth suggests the eager, though pugnacious, conversationalist. He has captured the energy of his intellect on canvas.

In a letter to his friend Michel Leiris, Bacon wrote that "It may be that realism, in its most profound expression, is always subjective" (Leiris, p. 13). This observation is a help when considering the artist's portraiture. We must believe him in his search for the very basis of a personality yet remember, like him, the many possible interpretations of the psyche being unravelled by twentieth-century psychologists. All we can do is appreciate Bacon's desire to eschew the society painter's reliance on mere illustration in favour of an image "more poignantly like" his sitter (Tate, p. 11).

Bacon's portraits are formed by a combination of accident and control. In the initial stages they contain literal information, then he introduces deliberate distortions in an attempt to capture the essence of a personality. As is apparent in this self-portrait, he risked throwing paint at the canvas, gouging at it with his fingers, manipulating it with rags, seizing at every "chance" effect in his move towards the non–illustrational form, wanting it to work "first upon sensation and then slowly (leak) back into the fact" (Sylvester, p. 56). He was fascinated by human behaviour and tried always to capture its

FRANCIS BACON

Self-Portrait, 1973

mercurial quality, often comparing himself to the caricaturist whose method is to fasten upon a particular facet of the personality with merciless emphasis.

FRANCIS BACON was born in Dublin of English parents and spent a peripatetic childhood travelling between Ireland and England. He received no formal art training but while in Paris, in 1928, he was much impressed by Picasso's work. Returning to London he began designing for interiors and, with the encouragement of the artist Roy de Maistre, painting. During the 1930s his pictures came to the attention of the critic Herbert Read and also to that of the art collector Sir Michael Sadler who bought a picture from him. Yet outside this select circle he remained unknown despite, in 1937, being included in a mixed show of British art at Agnews. Soon after this he destroyed the bulk of his work and stopped painting until 1944, when he burst upon the art scene again with *Study for Three Figures at the base of a Crucifixion* which was purchased by the Tate Gallery. In 1948 the Museum of Modern Art, New York bought *Painting 1946* and, as a result, he became known in the United States. The impression created by these brutally suggestive pictures of the 1940s – with their themes of death and suffering – remained long in the public's consciousness. Bacon took a different attitude towards this work, referring to the beauty of dead flesh presented (as meat) in a butcher's shop and questioning the public's muddled thinking – their abhorrence, for example, of bull-fighting expressed while they dressed themselves in fur coats and sported feathers in their hats.

The main body of Bacon's later work is concerned with figures in a cell-like space. Here they become considerably more distorted – in line with his portraits – while the rooms are severely geometric and realistic. This sets up a tension in which the figures make urgent, passionate, individual gestures to which the cool geometry of the room denies all meaning. Bacon believed that with the lack of any "religious possibilities" (Sylvester, p. 30) man now realised that "he is an accident, that he is a completely futile being, that he has to play the game without reason" (Sylvester, p. 28). He takes to an extreme, in its most modern idiom, not only the despair that springs from the loss of confidence stemming from Darwin's reinterpretation of the Universe, but beyond that a much deeper despair issuing from modern man's total lack of belief in himself as an entity. Not only does human life have no meaning, humans themselves can scarcely be said to exist. Beyond this Bacon denied having any message to convey, arguing that he painted for himself and that if he had not been successful he would have earned a living another way. This, if anything, was his message.

BIBLIOGRAPHY

LEIRIS, Michel *Francis Bacon* (Thames & Hudson, 1988)
ROTHENSTEIN, John *Modern English Painters: Wood to Hockney, III* (Macdonald and James, 1974)
RUSSELL, John *Francis Bacon* (Oxford University Press, 1979 edn)
SYLVESTER, David *The Brutality of Fact: Interviews with Francis Bacon* (Thames & Hudson, 1987 edn)
TATE GALLERY *Francis Bacon born 1909, an Introduction for Senior School Students* (1985)
TATE GALLERY, LIVERPOOL *Francis Bacon* (1990)

David Hockney (b. 1937)

Henry in Italy, 1973

PEN AND INK ON PAPER
35.5 × 43 cm (14 × 17 ins)
HIRSHHORN MUSEUM AND SCULPTURE GARDEN,
SMITHSONIAN INSTITUTION, WASHINGTON, D.C.

David Hockney is an artist whose portraits speak loudly to the viewer about his state of mind because they often exhibit cries of unassuaged pain – albeit untainted with the universal disillusion so prevalent in Francis Bacon's work – though like Bacon, and also like Auerbach, the need to express his own emotional state tends to dominate and therefore limit his work.

Looking at the many drawings of Henry Geldzahler (1935–95) that David Hockney has produced it comes as no surprise to learn that Geldzahler was the artist's closest friend in the United States. They knew each other for more than thirty years, spoke daily when Hockney was in New York, and frequently travelled together. Henry – as one compulsively calls him following the titles on so many of the drawings – was an art historian. He was born in Antwerp but later came to form an important part of the New York art world as a promoter of contemporary art, curator at the Metropolitan Museum, and Cultural Commissioner for the City. In 1976 he wrote the introduction to volume one of Hockney's autobiography in which he tellingly summed up the artist's recent series of double portraits (including one of himself) as exhibiting an "almost voyeuristic scrutiny of relationships" (Hockney, 1988, p. 22). Not only was he a sensitive critic, he inspired David Hockney's choice of literature too. It was he who suggested that the artist should read Wallace Stevens's poem 'The Man with the Blue Guitar' from which emanated a long series of etchings and several paintings. Hockney responded to Henry's humour, generosity and acute observation with a constant stream of drawings and prints of him together with two notable paintings.

During the 1970s, whilst suffering from a crisis of confidence over his painting, Hockney drew and made prints of his friends instead. Henry is seen amongst them bespectacled and bearded, frequently smoking a pipe or cigar, seated with one leg cocked over the opposite knee. His dress is always stylish: waistcoats, bow-ties, brightly-coloured holiday shirts, a panama hat – items of attire that make up his persona. However, there is more to these portraits than that: he stands out from Hockney's other male friends as relaxed and amiable with no 'side' to him. In the other portraits there is a constant tension, possibly because many of the sitters had been the artist's lovers, whereas Henry was always a friend. Henry exudes energy which the 'sit' of his head helps to denote; it pivots easily as he turns this way and that in the different pictures, giving an impression of his alertness, intelligence, and interest in the world. Hockney himself is thoroughly interested in his surroundings and in ideas and there is an audible 'zing' between him and his sitter. In fact, these works on paper of Henry are a fascinating key to the earlier double portrait of him (*Henry Geldzahler and Christopher Scott*, 1969) where he is obviously

communicating with Hockney outside that canvas whilst positively ignoring his stiff-backed lover, Christopher Scott, within the painted room. Geldzahler and Hockney are acknowledged homosexuals who perhaps have divorced their sexual needs from their intellectual requirements, thus not often achieving a rounded relationship with their lovers.

This portrait drawing of Henry Geldzahler, *Henry in Italy* shows him relaxing there in the August heat. He is in holiday mood reclining easily in a garden chair having shifted his weight into a corner of it for maximum space and comfort. Yet his features are alert and a slipper dangles from his right foot: he and the artist are in conversation, enjoying each other's company. If Hockney had omitted Henry's swinging foot the lower part of the drawing might have been rather dull. Instead, it and its footware add interest and elegance to the whole; moreover, one can feel their weight and texture. As he once said in an interview: "A black line has to express volume, space, form – everything" (*The Observer*). The black ink lines of this drawing express colour too: Henry's checked shirt, hair, beard, cigar and book are richly suggestive of their individual identities: another key to the artist's approach to his work is indicated. Throughout his career Hockney has admitted to having had difficulties with paint – both acrylic and oil paint have caused him problems and crises as they lack, for him, the spontaneity and imaginative possibilities of the drawn line. Indeed, he has admitted that he finds "Colour is the most fugitive element of a picture. It's fugitive in life and it's fugitive in the physical reality of the picture. We can remember that it was red, but we cannot remember exactly what kind of red; this is why I think black and white pictures work best, because, in a sense, we are more attuned to lines and what they do, than to colours and what they do" (Livingstone, foreword, 1987). Looking at the many portrait drawings Hockney has made in pen and ink and as prints (and not forgetting the marvellous crayon drawings and the coloured lithographs where the colour is a charming scribble), it is hard to argue with his friend Ron Kitaj's view that he is the finest living draughtsman of the human figure. Drawings such as *Henry in Italy* require outstanding ability for they have to be drawn in one sitting and there is no room for error. Ink cannot be erased and the totality of an outline has to be completed before the pen can leave the paper. To achieve this great concentration is required, together with a clear understanding of the human form, and an eye for composition. Of all his work in different media, line drawing is probably the most demanding and many sheets of paper have been abandoned in the attempt; never, though, does Hockney despair as he sometimes does over his paintings. Just why this is so becomes more apparent when one considers his artistic career.

DAVID HOCKNEY is an artist who cannot stop asking questions about how he, and we, look at the world. For this reason he is constantly describing it in different ways. This curiosity is at the heart of his artistic activity and only with this aspect of his work in mind can his pictures be viewed at all coherently.

Since his student days Picasso has been Hockney's artistic mentor, and from him he has taken the cue that it is permissible to be a stylistic "magpie". To begin with this was something of a game for, in 1960, to be seen to espouse figuration was to risk being ostracised. Therefore his paintings were, to all intents and purposes, abstract yet the child-like graffiti scrawled over them carried potent allusions that gave them a sense of form and meaning. Hockney may have adopted this approach as an exercise in self-preservation but

71

he was certainly not cowed by the threat of being cold-shouldered and used the style to express, wittily, both his real attitude to the figurative and to his own homosexuality. Like Picasso, he has always needed his pictures to carry some sort of intellectual challenge, much of which has been to do with the difference between the surface of the canvas and the real world. He has had, for example, a continuous dialogue with his intellect regarding the merits and demerits of photography, viewing it as too mechanical, monotonous, and untruthful to last, deploring the fact that, when describing a face, a photograph usually omits information about its weight and volume, leaving it flat. Yet he has challenged photography to come alive for him by creating collages from it to produce a 'history' of a person or of a scene which, he has also argued, only the long, slow processes of the artist can really achieve. "A photograph takes a split second, at the most a few minutes, and describes so little time. Whereas a painting can take months" (*New Yorker*).

Hockney's fascination with the formulation of water, which developed whilst he was living in California in the 1960s, led to a series of witty conclusions in the form of showers, swimming-pools, and water-sprinklers. They show his continual involvement with the various illusions of surface caused by the actions of the water.

In recent years he has become transfixed by photocopiers, faxes and computers, experimenting in each instance with the immediacy of his thoughts on a given surface, not wanting them to be diluted by the intervention of some other printed media before they reach the spectator's eye. He has been obsessed, too, with perspective, laughingly painting picture postcard landscapes of California that could arguably also be read as two-dimensional, then moving on to a consideration of Renaissance one-point perspective in his double portrait series, and later involving himself with inverted perspective as a way of enabling the spectator to be incorporated into the picture's space.

It is always exciting to see an artist's quest for the truth, as he sees it, and there is no doubting Hockney's sincerity. However, it is easy to feel rather disappointed with his varying experiments. Some of the recently painted landscapes are an uneasy mixture of the abstract and the real. The colours are unpleasant and there is no sense of tone. Hockney is anxious to involve the spectator through his handling of perspective, but has failed to do so because the pictures have no atmosphere.

By far the most interesting works by him are the Californian pictures of the mid-1960s, the double portraits on canvas (1968–77), and the prints and drawings. Hockney's Californian gardens and pools have a fairly unified sense of tone which creates a feeling of harmony in a series of canvases otherwise replete with overtones and charged with atmosphere whose significance it is difficult to determine. They, and the double portraits, arrest our attention because of the incipient narrative contained in them, though in such instances it is a spurious challenge to thought because the narrative has nothing to do with painting.

The double portraits Hockney painted in California and elsewhere, explore relationships between married couples and homosexual partners. These are both ingenious and disquieting – disquieting because of the obvious *frisson* felt by the artist over the volatility of some of the relationships for Hockney understands only too well the inevitable loneliness that can follow: "If I described my own, as it were, suffering, it would be about loneliness. There are times when one feels intensely lonely . . . " (Hockney, 1993, p. 137). This loneliness appears to be ever-present, even if at a subliminal level, and it prevents him painting objectively; his pictures are always

DAVID HOCKNEY
Henry in Italy, 1973

overloaded with human feeling. At this period, he went through one affair after another and it is only too clear that his emotions were affecting how he painted.

As David Hockney has freely admitted, the drawn line is, for him, an easier medium in which to work and all his prints and drawings exhibit freshness, spontaneity, elegance, and charm as well as, in the case of the portraits, an incisive comment on character. In them he is able to be objective because the discipline of the medium has the marvellously astringent effect of forcing him to control and direct his emotions. More than one critic has attested to his skill as a draughtsman. As Frances Spalding has written: "Like Ingres, Hockney may come to be admired chiefly for his portraits and draughtsmanship . . . He excels, in particular, with pen-and-ink. His line is brittle yet tender, economical yet sensitive to the smallest nuance" (Spalding, p. 202).

BIBLIOGRAPHY

FULLER, Peter *Modern Painters* (Methuen, 1993)

HOCKNEY, David *David Hockney by David Hockney: My Early Years* (edited by Nikos Stangos, Thames & Hudson, 1988 edition) *That's The Way I See It* (edited by Nikos Stangos, Thames & Hudson, 1993)

LIVINGSTONE, Marco *David Hockney* (Thames & Hudson, 1981) *David Hockney Faces 1966–1984* (1987)

MELIA, Paul & LUCKHARDT, Ulrich *David Hockney Paintings* (Prestel, Munich/New York, 1994)

NEW YORKER Profile by Anthony Bailey, July 1979

THE OBSERVER 28 November 1971

PILLSBURY, Edmund *David Hockney Travels with Pen, Pencil and Ink* (Introduction) (Petersburg Press, 1978)

ROTHENSTEIN, John *Modern English Painters, III* (Macdonald and James, 1976)

SPALDING, Frances *British Art Since 1900* (Thames & Hudson, 1986)

Tom Phillips (b. 1937)

Dame Iris Murdoch, 1984–6

OIL ON CANVAS

76.2 × 55.9 cm (30 × 22 ins)

NATIONAL PORTRAIT GALLERY, LONDON

Three painters in this book reflect the public's continuing need for accessibility to portraiture: Lavery, Knight and Tom Phillips. In their day, Lavery and Knight were regarded by some as extremely go-ahead – the acme of fashion. Today, Phillips has donned their mantle. It is as if there are two paralled strands running through British twentieth-century portraiture – the one revealing a fashionable cleverness, as in these three artists, the other (the real milestones) laying bare the deeper-seated mood of the moment.

On the face of it would appear that Dame Iris Murdoch and Tom Phillips are ideally suited to each other as sitter and portraitist as both intellectualise what they see. On the one hand is Dame Iris, who was born in Dublin in 1919, studied classics at Oxford – later returning there to teach and write on philosophy – and who has also published many psychologically analytical novels, while on the other is Phillips who is well-known for his questing mind. However the portrait that has resulted from their encounter has met with mixed criticism: two vivid and totally opposing views will serve to demonstrate its reception. Waldemar Januszczak considered it to be "a work of obvious thoughtfulness and ambition" in which the sitter is endowed "with the dignity of a Venetian Doge" (RA, p. 188) while Brian Sewell found it a deplorable work replete with symbolism which he felt created a composition of "dreadful disunity" in which "poor jaundiced-eyed Miss Murdoch is as flat and grainy as an overblown holiday snap" (ibid.).

The National Portrait Gallery is well aware that full-time portrait painters are in danger of becoming hacks and it was for this reason that they commissioned Tom Phillips to paint Dame Iris to add to their Twentieth Century Galleries. The result from this non-professional portraitist is a mixture of the expected and the unusual, as critical opinion implies. It is a public commission perhaps too full of private references needing explanation. For example, the inclusion of the gingko tree in the foreground is as oddly sophisticated as anything in a sixteenth-century Italian Ducal art collection, while the sitter's face falls more into the category of traditional portraiture, though that 'speaking likeness' expected from the best portraits is absent. In fact, to describe Dame Iris as having the "dignity of a Venetian Doge" is quite apt. This fits in with the expectations of a public commission; it sets her on a pinnacle as philosopher, teacher and novelist, more identified than humanised.

The trouble with this picture is that it falls apart both intellectually and compositionally. The gingko, as indicated, and the backdrop – a copy of Titian's *The Flaying of Marsyas* – are much too esoteric for a contemporary public portrait. We know that Dame Iris Murdoch is a writer and a thinker, but we need a written explanation to understand the symbolism which Phillips has included in the piece. We have to be told

TOM PHILLIPS

Dame Iris Murdoch, 1984–6

that when the artist and writer first met they had both recently seen the Titian painting and found it interesting and admirable. Prompted by this recent experience Phillips, no doubt, found it intellectually titillating to think of the novelist as a flayer of human souls. It has to be explained to us that the two love gingko trees. All is highly contrived and, appropriate as some critics may have found both symbols in elucidating Dame Iris's career, it is too clever by half.

The composition of the portrait is a problem for a number of reasons. Phillips's handling of space is odd: the 'Titian' painting seems to sit on Dame Iris's head while the gingko appears from nowhere. Between them the sitter is suffocated and space does not exist at a functional level. The placing of the sitter's head on the canvas is reminiscent of a person being interviewed on a television screen and yet that 'person' fails to communicate with anyone. Phillips has described his sitter as an icon and deliberately made adjustments to her pose to create one. In comparison with the photograph taken of the picture being painted, in which Dame Iris has a friendly tilt to her head and a comfortable cardigan on her back, all is intellectual and cold; there is nothing organic or intuitive about the composition. Equally discordant is the artist's use of colour and tone. The shrill green gingko is unnatural, even menacing, not at all like Murdoch's descriptions of the countryside. And when one stands before the picture in the National Portrait Gallery, the tonalities of her hair and those in the 'Titian' clash uneasily. This portrait is not alone among Phillips's work in producing a sense of discomfort, whereas his less pretentious preparatory sketches appear to have much more life in them.

TOM PHILLIPS has been a Royal Academician since 1989 but he is not solely a painter: he is a composer, translator and writer as well. Having read English Literature at St. Catherine's College, Oxford he went on to study at Camberwell School of Art. At both establishments he mixed widely with others interested in the arts in their broadest sense.

In 1973 the critic John Russell said of Phillips: "Not for a long time have we had so astute a setter-up of conundrums, nor so dextrous a manipulator of meaning within meaning, allusion within allusion, secret within secret" (Marlborough, p. 5). Thus, Russell has exposed the artist's style: it is essentially intellectual and esoteric, so much so that Phillips provides his own catalogue commentaries each time his paintings are exhibited. Moreover, and perhaps involuntarily, his vocabulary gives him away: he talks of "cataloguing", "collecting" and "formats". His notion of implementing the great tradition of art is to stitch together fragments of other artists' and writers' work, while his idea of chance is to make artistic decisions by spinning a coin: it will be seen that for Maggi Hambling chance is in the throwing of paint.

Postcards, stencils, left-over paint and pastel, and the use of collage, are just a few of the ingredients found in Tom Phillips's oeuvre. It fascinates him to work in series letting his theme evolve with time. Typical of his use of conundrums is *A Humument* (1966–) an on-going series of pictures created by cannibalising the pages of the Victorian novel *A Human Document* by W. H. Mallock. A large part of the typeface on each page is painted over in gouache leaving the remaining words and phrases to form a new narrative. Equally painstaking has been *Curriculum Vitae*, a series begun in 1986. It is the written story of his childhood, a laboriously crafted text in paint with a pictorial background, which yields its secret with difficulty, being replete with Phillip's love of manipulated language. Yet it, too, is provided with an "exhaustive exegesis" a practice which made the

critic Pat Gilmour wonder sometime ago whether Phillips felt that his work in general "might not make it" without such explanations (*Arts Review*, pp. 34–5).

Another extremely ambitious project has been Phillip's translation of and illustrations for Dante's *Inferno* and its production as a limited edition 'deluxe' art book. In 1988 he began working on a television version of it with the film director Peter Greenaway in whom he felt "that he had met his match. This is because of their shared love of allusions and conundrums and their pleasure in the use of sophisticated animated graphics for the series.

Not until the 1980s did Tom Phillips add portraiture to his list of accomplishments, and while he has been accorded great praise for it he has had his detractors too. Typical of the criticisms is William Packer's observation that he is "rather more dutiful than intuitive a painter of portraits" (*Financial Times*). As apposite is Richard Shone's view that when Phillips uses "Too many colours, unrelated in tone, (they) reduce particular heads to bitty, incoherent surfaces . . . (and when he uses) too few, . . . the heads become flat and over-graphic" (*Burlington*, pp. 51–2). Indeed, the head of Dame Iris Murdoch is both "dutiful" and "incoherent". The two were indeed well-suited although not in the way the National Portrait Gallery hoped: both the characters of the one and the portraits of the other lack the vital spark. What imagination either has appears to be strangulated by a tyrannic self-consciousness and an uncritical, self-indulging attendance on this self-consciousness. The man, and his preconceptions about himself and his sitter, blocks almost entirely the artist's perception of who – or what – is in front of his eyes.

BIBLIOGRAPHY

ARTS REVIEW Pat Gilmour (2 February 1979) Jane Norrie (12 January 1990)
BURLINGTON Richard Shone (January 1990)
COUNTRY LIFE Portraits with Presence – David Lee (5 October 1989)
FINANCIAL TIMES William Packer, 10 March 1987
MARLBOROUGH GALLERY *Tom Phillips* – John Russell (1973)
NATIONAL PORTRAIT GALLERY *Tom Phillips: The Portrait Works* (1989)
ROYAL ACADEMY OF ART *Tom Phillips Works and Texts* (1992)

Maggi Hambling (b. 1945)

Professor Dorothy Hodgkin, 1985

OIL ON CANVAS

93.2 × 76 cm (36 3/4 × 30 ins)

NATIONAL PORTRAIT GALLERY, LONDON

In Britain the Establishment has been slow to blazon abroad the achievements of women in the less conventionally female areas of work. Long may it have been acceptable for them to write novels or become actresses, but female architects, doctors, prime ministers or scientists have had to face hostile unease from the greater world. One branch of the Establishment – the National Portrait Gallery – waited until 1985 before commissioning a portrait of a woman scientist – Professor Dorothy Hodgkin – despite the fact that in 1934 (aged twenty-four) she was appointed Tutor in Chemistry at Somerville College, Oxford. Thereafter her career progressed rapidly: in 1947 she was elected one of the first female members of the Royal Society and in 1964 she was awarded the Nobel Prize for Chemistry. The following year she received the Order of Merit, the only woman since Florence Nightingale to have been honoured. Her teaching, together with her pioneering work on the chemical structure of penicillin, vitamin B12, and insulin, have acted as an inspiration to other women scientists, and her life sums up the changing attitudes to women that have occurred since her birth in 1910.

An artist of any merit who sets out to paint a 'public' portrait today is faced with a radically different set of rules from those which held fifty years ago; television and press photographers have probed into the private lives of the famous, caught them off their guard, and removed from them the awe and respect they had previously, and automatically, received. Now, their private faces and private habits have become pre-eminent in the public's consciousness and degrees of sensation a prerequisite of any 'interesting' portrait. This invasion of privacy is not accompanied by any sense of obligation – that if one is allowed 'in' one must bring to the invasion a seriousness and respect: a concern with values and the capacity to perceive. 'Fools rush in' whenever the itch urges. Given such aggressive and unqualified expectations, it is difficult for an intelligent, imaginative artist to succeed in conveying to the spectator the public achievements of their sitter – the usual guidelines of dress and symbols say little to the modern viewer reared on the media. However, Maggi Hambling's portrait of Professor Hodgkin meets this challenge and triumphs over it for, when tackling portrait painting, the artist has never been attracted to the fashions and fads of the moment and her presentations of the human face have, like Sutherland's, been charged with significance and sympathy. Modern in her attitude to life she yet remains in touch with the profound, and historical, rhythms of existence.

A key to the success of this portrait is contained in an observation made about Hambling's work by Paul Bailey: "her people are presented with such depth, disinterestedly" (Arts Council, p. 38) and in another made by the artist herself: "You can't paint anything unless you're at one with the thing, it's inside you, it obsesses you"

(Northern Centre, p. 21). It could be argued that these two statements contradict each other, but, in fact, they marvellously coalesce. The overwhelming quality of the picture is complete absorption. The artist has understood the sitter's total commitment to her work and sought to picture that as the Professor's essential characteristic rather than bringing any aspect of her face to our attention. In a way, the face is generalised: we don't know the colour of her eyes or what her complexion is truly like, we only know about her work and how much she enjoys it. But if the face is generalised the hands are not and if Maggi Hambling is "obsessed" with them it is for a reason. By painting two pairs of hands she has described brilliantly the qualities that led to Professor Hodgkin's public success: hard work and a delight in it. As Hambling has said, they are "like busy little animals, always on the go, moving about in every direction" (*Art & Artists*). So, one pair severally holds a magnifying glass and points at the typing on the computer print-out, while the other pair holds a piece of paper and makes notes from it. Through these means Hambling's 'obsession' and disinterestedness are fused and the paradox resolved.

Although Maggi Hambling has conceded to the media's manner of depicting public figures she only remains in accord with this fashion at a superficial level. The Professor may not have visited the hairdresser before allowing her portrait to commence, and she may not be dressed formally, but all around her is her work which has created her reputation. The composition of the picture is such that almost every part of it is crammed with books, papers and structural models while the perspective of the writing table is purposely tilted towards us allowing us to understand primarily the Professor's public persona, though not to enter too far into her private life. There is no danger of her wayward hair or casual clothing unlocking any privacies about her, while that other personal note, the arthritic hands – an affliction from which she suffered for most of her adult life – only adds to her public stature swelling her achievements. Implicit in the portrait are other aspects of her public career: for many years she was involved with an international movement of scientists working for peace and her study, described in soft tones, and the quiet, snowy landscape outside allude to this. Above all, this portrait succeeds in uniting the dual themes of intellectual energy and actual peace.

A characteristic linking the majority of artists in this book is that few of them have had to earn their living exclusively from portraiture or have been forced to struggle with its pressures on their artistic integrity. In the case of Maggi Hambling's portraits, she is clearly a painter at her best with the different or unusual type of sitter; those who inspire her by their character or achievements. Certain of her portraits of men in positions of various sorts of authority are dull, the subjects seeming bereft of an inner energy. Indeed, her friend, George Melly, has made a slightly ambiguous remark about her commissioned portraits; he has said that they "ensure her a certain security yet remain honourable pictures" (Northern Centre, p. 10). Perhaps. Occasionally, she has painted a sitter against her better judgement and it remains "honourable" enough. However, this was not the case with Professor Hodgkin whom she has described as "one of the most important and genuinely enlightened people of our time, and I wanted to convey this sense of her. It's almost as though she were an ancient alchemist, making magic. At least it's magic to me" (*Art & Artists*).

It is interesting to compare Professor Hodgkin's portrait with that of Sir Winston Churchill (see p. 52). Thirty years separates them, yet certain criteria for judging these likenesses remain constant. Above all it is vital to understand the sitter's role in life, only

MAGGI HAMBLING

Professor Dorothy Hodgkin, 1985

then can the artist's interpretation be fully appreciated. The public response to Graham Sutherland's 1954 portrait of Churchill was one of shock. Yet, looking at it now, it is clear that the Prime Minister's private life was not invaded as was suggested. Instead his unique strength is described through the picture: a determination, at all costs to himself, to defeat the Nazi threat to Britain and to keep the fragile peace that ensued. Conversely, Professor Hodgkin's work involved scientific analysis rather than emotional engagements with people and she communicated her findings and opinions through learned papers and through teaching. Her public and personal lives did not overlap in the same way as aspects of Churchill's did. All the same, Maggi Hambling has been careful, like Sutherland, not to pry in the journalistic sense: only what is relevant to the commission is put on public show together with those fundamental, unchanging elements which make for human greatness. Possibly the integrity and dispassionate concentration in the true artist meeting a corresponding integrity and dispassionateness in his – and her – sitter, accounts for the astonishing power of these two portraits.

MAGGI HAMBLING was born in Hadleigh, Suffolk in 1945 and while still a teenager frequented the East Anglian School of Painting and Drawing run by Sir Cedric Morris and Lett Haines. Haines became her mentor and advised her to draw constantly and pay attention to her dreams. During the 1960s she attended first Ipswich and then Camberwell Schools of Art and finally the Slade. Since 1973 she has frequently exhibited her work. Between 1980 and 1981 she was the National Gallery's first Artist-in-Residence and that, and her many colourful television appearances, made her known.

Although principally a figurative artist, Maggi Hambling's work is very varied. She experiments constantly, most recently with a series of sculptures. She is particularly interested in characters at odds with convention. Her work of the 1980s included a series of portraits of the vaudeville actor Max Wall, and another depicting Spanish bullfights. In his consideration of them, the critic Peter Fuller described how she has 'transfigured' both themes. Often her humans and animals are seen on their own struggling with life: "She has a sense of the heroic, . . . she responds to it above all in a tragic shape. She never mocks, never condescends" commented Marina Warner (Arts Council, p. 14).

Over the years Maggi Hambling has studied how and why people laugh and seen in it both a comic and a tragic aspect. In 1976 she painted Lett Haines laughing in a striking, though still immature, portrait. But since then her observations of this human phenomenon have led her in the direction of abstraction. The media used for this work have been watercolour and masking fluid applied with abandon, allowing chance to dictate the results which she has then titled. The artist has adopted a similar method in her *Mud Dream* series, which arose from a dream she had in 1990. Perhaps laughter and dreams share an element of the shapeless and the irrational akin to chance and are well-served by abstraction.

The East Anglian sky has inspired her too and each summer since the mid-1980s Hambling has spent time studying the sunrise on the River Orwell. For her this announcement of day is a transfiguration, evoking a powerful emotion. Her watercolours of it have become the basis for oil paintings which, on the one hand, have made a statement and, on the other, liberated a hitherto rather sombre palette.

Drawing has always been fundamental to everything Hambling has achieved in her

art while at times her imagination has led her to use elements of symbolism in her pictures or, in the case of Professor Hodgkin's hands, to employ an imaginative licence.

BIBLIOGRAPHY

ART & ARTISTS 'In Celebration: Judith Bumpus talks to Maggi Hambling about her portrait of Professor Dorothy Hodgkin' (September 1985)

ARTS COUNCIL (Serpentine Gallery) Maggi Hambling, Paintings, Drawings and Watercolours (1987)

FULLER, Peter *Modern Painters* (Methuen, 1993)

NORTHERN CENTRE FOR CONTEMPORARY ARTS *Towards Laughter: Maggi Hambling* (1993)

YALE CENTER FOR BRITISH ART *Maggi Hambling: An Eye through a Decade, 1981–1991* (1991)

Lucian Freud (b. 1922)

Night Portrait, 1985–86

OIL ON CANVAS
92.7 × 76.2 cm (36¹/₂ × 30 ins)
HIRSHHORN MUSEUM AND SCULPTURE GARDEN,
SMITHSONIAN INSTITUTION, WASHINGTON, D.C.

Frank Auerbach, Francis Bacon and Lucian Freud all hold broadly similar attitudes towards the depiction of the human face. In their portrait painting they prefer it to occupy a somewhat secondary role, to be clothed in anonymity. Yet a verbal description of Lucian Freud's art would contain in contrast, say, to the work of Bacon or Auerbach, or even Bellany, the words 'realist' and 'portrait painter', though once one looks at his pictures surprises emerge. Freud does not paint what, from an historical perspective of art history, would be called traditional realist portraits – namely portraits that are principally descriptions of the sitter's occupation, interests, background and character. Instead, he explores the silent, private world of his subject: what happens to a person when they relax. Frequently, therefore, there is no longer the traditional dialogue between sitter, artist and spectator: this is replaced by introspection and a far-away gaze. The body, like never before in so many canvases, is shown naked and often lying prone, thus exposing all the usual unsightly corners of the human anatomy that clothes so successfully hide.

Freud's paintings are usually of people whom he knows well – people prepared to spend hours in his studio while he paints them. His many nude canvases, such as *Night Portrait*, are of friends and family too, not just studies of a model. For he has stated, specifically, that the 'animal' part of the human body is every bit as essential a part of the history of that person as is the head because "I have watched behaviour change human forms" (South Bank Centre, p. 20). Normally, though the sitter's identity remains anonymous.

This painting depicts the artist's total command over his composition and use of paint. His sitter is seen from above, scrutinised by Freud the historian of the human body. At first glance the pose looks uncomfortable, it is, however, true to life and repeated, with variations, by the artist in many of his naked portraits allowing him the opportunity to paint interesting shapes and to juxtapose them to the other objects in his composition. These are normally kept to a minimum, only there to add texture and contrast to the body. Usually they include a pillow, sheet, a bedspread – flesh against pale colours – and always the paint is luscious. In *Night Portrait* attention is drawn to the different set of lines on the body – bones, muscles, skin – as opposed to the heavier folds of the draped sheet, the wrinkled effect of the mattress, and the gleaming floorboards receding into the distance. The placing of the figure on the canvas is superbly judged. Often, in such works, Freud paints the face last of all because he wants the body to convey that person's expression – "The head must just be another limb" (Hughes, p. 20). In this picture he demonstrates his characteristic objectivity towards his subject, for the head is following the dictates of the body: it, too, is anchored to the bed while the eyes stare blankly into the distance.

LUCIAN FREUD

Night Portrait, 1985–6

LUCIAN FREUD, of Austrian-Jewish stock, and the grandson of Sigmund Freud, was born in Berlin. He lived there, witnessing the emergence of Nazism, until his parents emigrated to England in 1933. His early experiences developed in him a need for solitude and privacy, apparent now in his working habits and social attitudes. His real biography lies hidden in his art amongst those friendly sitters whom he has involved in such lengthy scrutiny. Freud attended the Central School of Art in London and spent time at Sir Cedric Morris's school in Suffolk. His early work shows similarities with both the Surrealist movement and the Berlin-based Neue Sachlichkeit – art historical observations which, now, he prefers to overlook as too simple an analysis of his development. By the 1960s his tight, linear style loosened considerably, in tandem with a growing interest in the structure of the human body and the skin that clothes it. Thenceforward the naked figure has become an important part of his contribution to the history of portrait painting.

In his monograph on the artist, Robert Hughes has outlined Freud's artistic aims as being "to assert, with the utmost plastic force, the advantages of scrutiny over theatre, without for a moment falling into the formalist trap of regarding the body as a mere inventory and potentially abstract form, or the idealist one of mistaking it for a cultural construct without pores or orifices, without the sag and sheen of flesh – without, in sum, the humanity that Freud's art so alertly hunts from the body's cover" (Hughes, p. 24).

Freud is not cold; but it is possible to feel a certain warm arrogance in his scrutiny, and a ruthlessness in his hunt for "the humanity." One is aware of these qualities both in the artist, and in the bodies vulnerable to his regard.

BIBLIOGRAPHY

BRITAIN TODAY Stanley Spencer and Lucian Freud, David Sylvester (no. 171, July 1950, pp. 36–9).
BRITISH COUNCIL, JAPAN *Lucien Freud* (April–September, 1992)
ENCOUNTER Some Thoughts on Painting – Lucian Freud (vol. III, no. 1, July 1954)
GOWING, Lawrence *Lucian Freud* (Thames & Hudson, 1982)
HAYWARD GALLERY *Lucian Freud* (1974)
HUGHES, Robert *Lucian Freud Paintings* (Thames & Hudson, 1989)
LESSORE, Helen *A Partial Testament: Essays on some Moderns in the Great Tradition* (Tate Gallery
 Publications, 1986)
SOUTH BANK CENTRE *Lucian Freud: Works on Paper* (1988)

Paula Rego (b. 1935)

Dr Germaine Greer, 1995

PASTEL ON PAPER LAID ON ALUMINIUM
120 × 111.1 cm (47¹/₂ × 43³/₄ ins)
NATIONAL PORTRAIT GALLERY, LONDON

In 1970 Dr Germaine Greer published a book that changed people's awareness of the nature of women as much as Lytton Strachey's *Eminent Victorians* had, in 1918, altered their attitudes towards the writing of biography. *The Female Eunuch*, described rather chauvinistically by the *Evening Standard* as "A manual of self-help for women-kind" (Greer, verso of jacket) introduced the world to Greer's no-nonsense, closely-argued polemic: it was like a breath of fresh air which allowed her "decently hatted and dressed" (Greer, p. 12) grass-roots supporters to stride confidently towards a new existence. Since then Germaine Greer has continued to write, lecture and broadcast and she remains a prominent champion of the feminist movement. She has written extensively on women artists and in *The Obstacle Race* (1979) examined the ways in which they pursued their profession prior to the 'feminist' revolution.

Paula Rego was born in 1935, just four years before Germaine Greer. Their lives produce illuminating parallels which may have prompted the National Portrait Gallery to have commissioned this portrait. Rego had never considered herself to be a portraitist and until 1995 had never undertaken commissions of this nature, yet events were slowly conspiring towards such an occasion. In 1988, Greer wrote a searching article for *Modern Painters* in which she observed: "It is not often given to women to recognise themselves in painting, still less to see their private world, their dreams, the insides of their heads, projected on such a scale and so immodestly, with such depth of colour. After the violation of Balthus's keyhole vision, feminists hardly dared to hope that a women painter could reassert woman's mystery and restore her intactness" (*Modern Painters*, p. 34). This article was written by Greer at the time of Rego's Serpentine Gallery Retrospective during which the public's attention was drawn towards the new direction being taken by Rego in her recent work. The difficult-to-read collages and graffiti-style acrylics had given way to a figurative art that was emotionally powerful, immediate and complex: it was one remove from daily life and yet an incisive comment on it.

As Germaine Greer explained in *The Female Eunuch*, women have to break the bonds of convention in order to release and maintain their personal identities: the subversive nature of her book was meant to catapult them into action. Growing up in a Portuguese society dominated by the dictates of the Roman Catholic church and run as a dictatorship, Paula Rego brought a more elliptical type of subversion to her paintings. She was used to, yet disliked, these rigorous methods of discipline both in private and in public life, and she saw how those who were subjugated – and particularly women – met class, gender or political domination with a resilient cunning. In the same way as David Hockney employed a sort of graffiti-style of painting in the early 1960s both to hide and to reveal his attitude to the world, Paula used the vehicle of the folk or fairy story,

together with a similar stylistic method, to express herself until the 1980s. Only then did her work become more explicit. Central to her thoughts has been the manner in which women cope with their lives. In the paintings exhibited at the Serpentine she showed them teetering on the brink of power, but it is an unspoken power. Only later, in the *Dog Women* series (1994), does the animal side of women exhibit itself in its most specific form, though this is not necessarily something that always brings with it triumph. Germaine Greer recognised the relevance of this aspect of Rego's work in an essay in *Tales from the National Gallery* (1991) where she wrote: "In Rego's hands the idealised human form undergoes humanisation. It no longer floats but lurks or squats or shoves" (National Gallery, p. 34). Years before Greer had discussed the animalism of women in *The Female Eunuch*, arguing that it is an essential part of their identity, something habitually denied by men who preferred the ideal and unsubstantial chimera of youth and immaturity to the tucks and wrinkles of the maternal or ageing woman.

So, by the time the National Portrait Gallery commissioned Dr Greer's portrait both she and Paula Rego had done much to heighten women's consciousness. Looking back at the other portraits of women in this book which are, at times, daringly modern in style or in their depictions of characters not noted for their timidity, this portrayal of Germaine Greer clamours for attention. This is partly because of its size, the clear and simple outline of the figure, and the fairly restricted range of colours in which the red and the black areas are devoid of fussy or prettifying detail. In the picture matter and manner are admirably fused. Greer's womanliness is light years away from the stridency even of Sargent's *Dame Ethel Smyth*. Here, a noted academic, knowing her portrait to be destined to hang in a public gallery, quite calmly chooses to wear a pair of old shoes with a hole in them and to sit rather inelegantly cross-legged on the floor exhibiting a pair of sturdy legs. Her clasped hands are large and strong, her hair dried-up, her face like leather, her chin angled and determined: she wears her beliefs on her sleeve. Executed in pastel, as was the earlier *Dog Woman* series, this equally tough portrayal of a woman has a beauty to it in the glaring truth that it tells about its subject.

Although this is Paula Rego's only publicly-known portrait she has an abiding interest in people and has frequently used her family and friends as starting-off points for her compositions. In discussing *Crivelli's Garden* (1991) − which she has described as a celebration of the courage of women − and which was commissioned for the National Gallery's restaurant, she has innumerated the sitters present in it but, typically, none of them look very like anyone. However, in much of her recent work Lila Nunes has been her model and in this and, indeed, in some early pictures done at the Slade School of Art, it is clear that Rego has a talent for portraiture. But the fact is that she does not particularly enjoy doing portraiture, and maybe only painted Germaine Greer because of their friendship and their shared opinions. Though fascinating from an historical point of view, this pairing of Rego and Greer has the mark of being too obvious. The commission was an extraoridinarily good idea, but the result is less than satisfactory. It is impossible to see both sides of the story; we only have one totally aligned feminist view. The National Portrait Gallery were after difference but they got sameness. Great portrait-making is a rare gift, only given to those possessed of an open mind and a generous heart: here the range is too narrow, there is no tension in the picture.

PAULA REGO was born in Portugal and brought up in comfortable circumstances. On

PAULA REGO

Dr Germaine Greer, 1995

the one hand her life was an ordered, disciplined, polite affair characteristic of the 1930s and 1940s there, while on the other it was enlivened by the peasant women she came to know at Ericeira, her grandparents' home. "They were ordinary women. They had powerful feelings but they were strong, you know, in character. Capable and practical. Not squeamish or lazy, or wanting recognition like men. They didn't shy away from hard work or dirty work. They could dress a chicken with their bare hands, rip it open and tear out the guts. They could get blood up to their elbows, if they needed to. That's the sort of women they were, just ordinary normal women with tough jobs who didn't make a fuss" (*Times Magazine*, 29 October 1994). In addition to the vivid contrast between drawing-room and kitchen Paula's family, and their servants also, possessed the art of story-telling. Her mother's tales were of friendly lizards, her father's of spooky, night-time creatures, while her aunt's took the form of real-life performances in terrifying disguises.

Paula's father was an Anglophile and he sent his daughter to the English school in Portugal. In 1952 he agreed to let her study at the Slade School of Art in London. There she entered a new world – bold and bohemian to her eyes – and one which introduced her to exciting new stimuli: the writings of Simone de Beauvoir and Henry Miller, while her favourite pursuit, the cinema, beckoned too. Here she met her future husband, the artist Victor Willing, who remained her mentor and sounding-board until his death in 1988.

Following the Portuguese Revolution of 1976 Rego made London her permanent home and is regarded along with Freud and Auerbach as an artist the British have claimed as their own. In 1985 she represented Britain at the São Paolo Biennale and in 1990 she became the National Gallery's first Artist in Residence. Early in her career both Sir Roland Penrose and David Sylvester noted her originality, but not until the 1980s did her art reach its maturity and it is significant that little of her work prior to this period was shown at her 1988 Retrospective. In his critique of that exhibition Brian Sewell doubted her technical abilities but those close to her – the Portuguese artist João Penalva and her husband – knew of her great talent at drawing. Over the last two decades she has demonstrated this more and more by abandoning working in collage and coming, in her most recent pictures, to use boldly coloured pastels. And, said Penalva, "What is so good about her work is that the images are so memorable" (McEwen, p. 111). But the laudation does not end there: John McEwen has described it not as illustration but as events. It is this that makes compositions such as *The Maids* (1987) or *The Family* (1988), and even her etchings of *English Nursery Rhymes* (1989), bristle with possibilities. No specific interpretation can be attached to these pictures. The domestic scenes they are largely concerned with show a state of flux; like life they offer choice or danger. They are, as is all her work, concerned with domination and with time.

Throughout her life, and partly because of her upbringing, Rego has preferred to speak her mind through her art. By using folk-tales, fairy-stories and animal imagery she has found a way to say the unsayable about our behaviour and emotions, to add new resonance to age-old situations. Her human characters are usually Portuguese. The women often plain, ungainly and inelegant; they are simple folk who speak to her heart. Sometimes they are half-child, half-woman, a mingling of innocence and experience. Striped bare of pretence they speak to the women of her adopted country – and to those in the United States too, where she has been exhibiting since the early 1980s. They "lurk, squat or shove" (National Gallery, p. 34) as women have always had the ability to do, but now they are more blatant, much to the discomfiture of men.

Since the 1980s Paula Rego's female characters – whether in the guise of an animal, as themselves, or exhibiting the animalistic aspects of their beings – have been used by her to portray the wide-ranging power of women. If women are prepared to employ this power then their potential, as she sees it, is infinite, for amongst their attributes are an instinct for survival, cunning, ruthlessness, charm, determination, practicality and endurance. Her paintings shock, frighten, arrest our attention: they are milestones to women's quest for their self-identity. Though not a portraitist in the same way as the other artists in this book, Paula Rego's depiction of Germaine Greer is the culmination of her exposition of the 'real' woman, and for that reason it takes its place among the milestones in twentieth century British portraiture.

BIBLIOGRAPHY

GREER, Germaine *The Female Eunuch* (Paladin, 1976 edn) *The Obstacle Race: The Fortunes of Women Painters and their Work* (Secker & Warburg, 1979)
McEWEN, John *Paula Rego* (Phaidon, 1997 edn)
MODERN PAINTERS Paula Rego, Germaine Greer (vol. i, no. 3, Autumn 1988)
THE NATIONAL GALLERY *Paula Rego, Tales from the National Gallery* (1991)
TIMES MAGAZINE Dogged Woman, Joanna Pitman (29 October 1994)

CHANGING PERCEPTIONS

If he were alive today, John Singer Sargent (1856–1925) would surely feel that the art of portrait painting had been turned up-side-down. Undoubtedly he would be shocked to see Francis Bacon's distorted faces and figures – shorn of any dignity or refinement. But, on further reflection, he would see that his successors had, like him, mirrored the world around them. Bold and daring sometimes in his own portraits, Sargent would certainly have admired the critical eyes of his most distinguished heirs. Never would he have agreed with the remark made in an Alan Bennett play: "as artists portrait painters don't really count. Not nowadays anyway", because the best of them, Bacon included, cut through the surface detail of everyday life to demonstrate a truth.[1] But what is it that has brought about the dramatic change in how portraits have come to be created during the twentieth century?

More than any other British painter of this century Francis Bacon (1909–92) reflects the beastliness of which mankind is capable. His life spanned three of the most shocking wars the world has known, each profoundly different in the way in which it affected the human race and these differences chart the changes in how men and women have come to see themselves and others. The Great War of 1914–18 – during Bacon's childhood – was a drawn-out affair that killed millions and maimed many minds, leaving men shell-shocked by the terrible events they endured. But it was a war fought on the battlefields, one in which civilians played little part and of which they learned only through newspaper reports and the long casualty lists. The war of 1939–45, on the other hand, left nobody's mind untouched and no civilian safe. It was fought in every corner of the world – in cities, villages, forests, deserts. It was fought with weapons that threatened

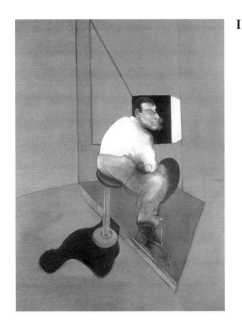

I

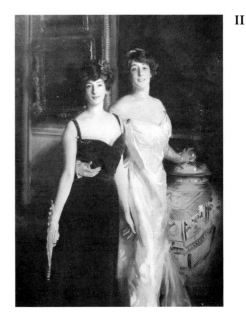

II

the annihilation of the human race and it culminated in the bombing of Hiroshima. But it was a conflict that rarely brought the fighting men face-to-face: the enemy was a mark on a map, not – until he, or she, was dead – a person. In 1991, when the Gulf War was fought, and Francis Bacon was nearing the end of his life, the monstrous weaponry forged over previous decades had become almost commonplace to our consciousnesses. Yet, as with the Great War, comparatively few civilians experienced its horrors, though, these horrors were seen – but not felt – by millions on television.

Around these wars then unfolded Bacon's life: during his infancy mankind's age-long certainties were fractured beyond recognition by the events of the Great War, and by the time of his death modern life had robbed several generations of the sense of continuity and stability that the world had always offered. To many people reality had become pictures presented on a highly selective television screen and the Gulf War, for instance, just another week's 'entertainment'.

Of all the figurative painters of this century Bacon reflects, most forcibly, these gigantic changes to our civilisation and to our consciousness. "I have found from personal experience," admitted one of his friends, "that his pictures help us, most powerfully, to feel the sheer fact of existence as it is sensed by a man without illusions."[2] Indeed, Bacon presents a man worn-down to a state of indifference in his *Study for a Portrait of John Edwards* (1985) (I). It is anything but a straightforward portrait. Little can be guessed of the history of the sitter: he lacks personal possessions, is seated in an hermetically sealed room, which could be anywhere, and exists in a mental vacuum. Only the architecture, the television screen and the swivel stool allow him to be 'placed', historically, as living in the latter part of the twentieth century. His mood reflects the creeping malaise of contemporary life – he is introverted and disconnected from the pulsations of the natural world.

How different to this is John Singer Sargent's *The Daughters of Asher Wertheimer Esquire* painted in 1901 (II). Both young women radiate assurance and poise and energy. They wear fine velvet and satin evening dresses, and they are painted in their father's drawing-room in Connaught Place surrounded by expensive antiques. Asher Wertheimer, a Jew, was a Bond Street art dealer, the type of quick-witted and cultured person that the cosmopolitan artist was readily drawn to. He became Sargent's greatest patron, no doubt in part because "Quicker than the Home Office, (Sargent) naturalised those who would otherwise have lingered in the between-world where class, nationality, money, and money's provenance, were matters not to be raised without a qualm".[3] Though this was the type of portrait that lured the British aristocracy to patronise the artist during the early 1900s, it was regarded as a little daring and unconventional when it was exhibited at the Royal Academy. Ena and Betty's 'antecedents', décolleté dresses, great liveliness and assertiveness were characteristics alien to fashionable portraiture. The critic of *The Magazine of Art* described their vivacity as "almost painful . . . I should not like to live in a room with these . . . almost breathing, faces looking at me from the walls, interesting as they are".[4] But it was the interest that the portrait engendered that stopped the critics in their tracks and, in the same way, Francis Bacon's work produces a similar response. To our modern eyes his painting of his friend John Edwards is a more serious picture than Sargent's of the Wertheimer girls, despite the sitter's inert and scruffy appearance. This picture, and the rest of Bacon's work since the Second World War, has come to seem more and more relevant to life as we now live it. Gone are the days when the rich habitually changed for dinner, as in Sargent's portrait; the Edwardian age of ease and

comfort has been replaced by a "world become more urgent".[5] Moreover, the speed of technological advance and its effect on daily life and on how wars have come to be fought, has left man without natural points of reference: he no longer has the back-up of traditional beliefs to help him to make sense of his existence. The pressure of these changes over the last hundred years have made the 'nothingness' in Bacon's portrait an apt comment upon life. But how is it that we have progressed from a state of paralysed horror in reaction to the experiences of the Great War to one almost of indifference in reaction to the television reports of the Gulf War?

The terrible Battle of the Somme (July–November 1916), the turning-point on the Western Front, made many realise the yawning gap in consciousness through which they had passed. On the one side was their blithe belief, held in August 1914, that the troops would be home for Christmas, and on the other was the realisation that past wars were mere nursery battles in comparison to this one. Reporting for *The Daily Chronicle* from the battlefield on the 14th of July Philip Gibbs wrote: "no man or woman would dare to speak again of war's 'glory', or of 'the splendour of war', or any of those lying phrases which hide the dreadful truth".[6]

Seen from the perspective of the battlefield a new world was emerging – one of total desolation. The enemies continuously engaged each other across No Man's Land, retreating to their respective trenches after each action, achieving little, even after three and a half years, except a world of rotting corpses. The poison gas that the Germans first used at Ypres in April 1916 did nothing to further their cause strategically, though its effect upon all the combatants was devastating and its contribution to the despoliation of the landscape great.

Coming from a civilisation seeped in the Christian tradition the scenes from the trenches must have seemed, for the British soldiers, as if from hell. "No pen or drawing can convey this country. Sunset and sunrise are blasphemous, they are mockeries to man, only the black rain out of the bruised and swollen clouds all through the bitter black night is fit atmosphere in such a land. The rain drives on, the stinking mud becomes more evilly yellow, the shell holes fill up with green-white water, the roads and tracks are covered in inches of slime, the black dying trees ooze and sweat and the shells never cease".[7] And to underline his graphic description Paul Nash later painted a picture of a scorched, polluted, alien landscape in which the charred tree stumps lift their withered limbs and seem to scream out in agony, while the earth looks riven as if by an earthquake. This he bitterly entitled, *We are Making a New World* (1918). A new world indeed! Sixty years earlier Charles Darwin had already announced that the earth was not in fact a demi-paradise provided by a benign God for his favourite creation – man. However, it is more than possible that Darwin's revolutionary theories on man's origins might have taken very much longer to seep down from the groups of scientists, anthropologists and academics interested in such matters to the general consciousness had not that consciousness been shattered beyond repair by the cataclysmic effects of this war. Now, even for the simplest Tommy existing as he could in Nash's 'New World', Darwin's version of our origins was infinitely more likely, if not more comforting, than that offered by the *Book of Genesis*. But Darwin could not have conceived of the effects of his findings on the human psyche bolstered as he was by an ethic, if not a religious conviction, absorbed from his genial Victorian upbringing. The Great War not only shattered man's former beliefs it also shattered the minds that had once held those beliefs.

In fact the outer desolation of the battlefield mirrored totally the inner desolation of those soldiers who were shell-shocked by war. Yet, at home, far away from the atmosphere at the Front, many people were still of the opinion that war was a glorious thing and that clean clothes and a good meal were sufficient to revive anyone. These are some of the themes underlying Wilfred Owen's poem 'Disabled' (1917) in which a severely wounded Tommy's disillusion and depression are explored. Like many, he had fantasised about joining-up, "Germans he scarcely thought of" until, crippled for life, he fetches up in an institution robbed of his youth, vitality and ability to communicate, fit only to "take whatever pity they may dole".[8] Doled out pity, this formula for the recovery of a scarred and scared mind, is proven useless; he is already slipping into a permanent mental decline. Wilfred Owen's poems examine the sights and sounds and smells of the battlefield and from his writings, as well as from those of others, comes an understanding of why some men's minds totally collapsed, why they became shell-shock victims. Writing home in the winter of 1917 Owen talks of "the distortion of the dead, whose unburiable bodies sit outside the dug-outs all day, all night, the most execrable sights on earth. In poetry we call them the most glorious. But to sit with them all day, all night . . . and a week later to come back and find them still sitting there, in motionless groups, THAT is what saps the 'soldierly spirit'".[9] Indeed, Owen soon found himself sheltering for a number of days, following a raid, in a shell hole accompanied by the dismembered, dead bodies of some fellow-officers. He, too, suffered shell-shock and was sent to Craiglockart War Hospital which had begun caring for neurasthenic patients.

At the outbreak of war 'cowardice' was still considered a disgrace and desertion punishable by shooting. The stiff upper-lip attitude of the military authorities, echoed by much of the public, did not recognise mental illness: emotions were foreign and unmanly. However, under the force of the growing evidence before their eyes they had, grudgingly, to begin to adjust their opinions. In 1918 Philip Morrell, MP – already viewed as a pariah in the House of Commons for arguing the cases of conscientious objectors – pleaded for medical aid to help shell-shock victims. Though the Government was persuaded to pay a disability pension to 65,000 neurasthenic soldiers after the war and a War Office Committee, set up to examine this newly-prevalent phenomenon, admitted in 1922 that, "seeming cowardice may be beyond the individual's control", neurasthenia was still an awkward, barely mentionable subject.[10]

Running parallel to these debates were ideas that had lain nascent in the minds of a few prior to 1914. As more and more soldiers were evacuated from the trenches, Aristotle's ancient dictum 'Know Thyself' was found to be reoccurring in a new discipline called psycho-analysis. At Craiglockart War Hospital the neurologist, Dr W. H. R. Rivers – familiar with the researches of Sigmund Freud – actively encouraged his patients to talk of their experiences and not to be ashamed of their responses to the carnage. Repressed fears and emotions made people ill; only by becoming familiar with what lay deep in their subconscious could they hope to avoid further trauma in the trenches to which they had to return.

Dr Rivers was fundamentally uneasy about this policy of rehabilitation to which he was a party – could any amount of psycho-analysis make a man happy in the trenches? So, too, was twenty-four year old Rebecca West. The title of her first novel, *The Return of the Soldier* (1918), echoes Rivers's ambivalence but her hero is trapped whichever way he turns. Returning home with shell-shock he is plunged back into an implicitly thankless

relationship with his wife, made even more unbridgeable because of his strange military experiences. 'Cured' of his amnesia, through the compassion of his erstwhile sweetheart and by a Freudian-trained doctor, he returns to the Front with, it is suggested, nothing in life to look forward to. Yet, ironically by 1918, the Front had a compulsive 'pull' for many fighting men: only there could they speak the same language as their fellow human beings, and this applied to both officers and men. They knew, as the cossetted civilian world did not, what it was like to live in hell. Comradeship and compassion, as Rebecca West had acknowledged in her novel, were the healing essentials of everyday life. But what lay beyond the cessation of hostilities? Certainly Carl Jung, by insisting upon the redemptive nature of man's age-old encounters with archetypes, offered more of a sense of the continuity of life than did Freud, but none of this was sufficient to take the place, once held, of the belief that man was made in God's image and that the world was made for man. Without such a sustaining sense of his significance man was less and less resistant to the creeping virus of futility. What is man? Why does he exist?

The First World War dispossessed everyone to a greater or lesser degree – geographically, emotionally, materially and functionally. But by November 1918, when the Armistice was declared, the position seemed more hopeful for women than it was for men. Before 1914 a factory inspector had felt quite confident in saying: "Women will never become engineers, mechanics, stonemasons, builders, miners and so on and men are not likely to become operatives, dressmakers, milliners or launderers", but after the war even he might have re-examined this statement.[11] The war had proved what women's champions had said all along: they were capable, strong and intellectually the equal of men. Given the vote in 1918 they could no longer be held back from participating in public life and from making something of the future. Mary Stocks's ringing declaration, "We have at last raised our skirts from the mud", encapsulates the physical changes that accompanied women's altering state.[12] In 1914 they wore dresses that reached the ground, put their hair up, and exhibited their femininity in a decorative and decorous manner. To look at them again in the mid-1920s is to be astonished: they wore short hair and short dresses with their necks, arms and legs exposed as never before. The daring Bright Young Things adorned their faces with lipstick and powder and their behaviour too, as Evelyn Waugh shows in *Vile Bodies*, lacked the propriety of their parents' generation: "girls seem to know so much nowadays" says a dowager wonderingly.[13] Those women who were serious, intelligent and thoughtful may have taken time to assert themselves through their gradual access to better education and through advances in domestic technology which freed them from the daily duties of the house, but nothing now could stop the change in their status.

Indeed the inter-war years were ones of transition both for women and for society in general. Ideas that had been tossed into the air in the heat of battle fermented slowly in reaction to the questioning of the habits of centuries. Bertrand Russell's condemnation of loyalty to country, discipline for children, and sexual repression, were typical of attitudes being examined at the time.

Nevertheless, shadowing the euphoria of liberation came nervousness and cynicism. People lived on the surface of life, or on its edge if they were affected personally by the Depression. John Singer Sargent's vision of Asher Wertheimer's assured daughters was becoming clouded and overlaid with the miasma of futility: the firm foundations of life were collapsing.

Already in the 1920s many thinking people realised how dangerously inept the Peace of Versailles had been. One, John Brophy predicted with alarming accuracy: "if another war should be jockeyed or forced upon the world, it will be a scientific, chemical affair; machines will be met with machines, not with the nerves and muscles of mere men. Later generations may see whole cities destroyed overnight, populations slain in their sleep; but they will not know winter in the Salient, or the summer shambles of the Somme, Gallipoli, and Mesopotamia."[14]

A question lies behind these words: would such a war be more or less horrible? Soldiers might no longer see the dismembered, decomposing bodies of their comrades strewn all over the trenches, or look impotently on at the "guttering, choking, drowning" death-throws of the gas victims; instead, they would come to learn by report, broadcast and photograph – though not through their own senses – of a bomb which by 1945 could kill hundreds of thousands of people at the touch of a button and whose presence could be seen and felt in the air up to 250 miles away.[15] Writing in her diary following the devastating bombings of Hiroshima and Nagasaki, the Countess of Ranfurly said: "It is so wonderful that World War II is over, and no wonder people celebrate, but what we have all done – to defend ourselves and to win the war – is too frightful for words."[16] "Wonderful" and "frightful" – this weapon was a double-edged sword offering a blessed release from a second ghastly war within twenty years, yet opening up the most terrifying questions about the future. Indeed, Hiroshima, like the Great War, acted as a watershed. A Japanese who survived the destruction of the city and its people later reflected on the terribly impersonal way in which this had occurred: "We were being killed against our will by something completely unknown to us . . . It is the misery of being thrown into a world of new terror and fear, a world more unknown than that of people sick with cancer."[17]

The shockwaves from the atomic bomb have reverberated ever since, bringing with them the most extraordinary changes in ethical and moral values since the birth of civilisation as we know it. The only discipline the world has come to respect is that of the nuclear deterrent, otherwise life is conducted, increasingly, on a laissez-faire basis. The defining moment for this in Britain was the 1960s, the era of the 'Permissive Society', during which abortion and homosexuality were declared legal, capital punishment was abolished, and the Pill introduced. The young, disenchanted by the future that their elders had fought for, drew comfort from the loosening of traditional shackles, allowed Pop music to dull the thoughts and sounds of the real world, and topped up their transitory happiness with the use of hallucinatory drugs. Increasingly, in the face of a growing, varying and vociferous population, scant thought was given to sensible social policies. In particular, the laws of the land – and specifically the ways in which they were administered – appeared, in the eyes of many, to have parted company with justice, while the insensitive transformation of town centres and the ubiquitous dependence on the motor car also stored up ghastly problems for the future. Imaginations seemed to have shrivelled in front of a new God – the television screen – which, ironically, offered people more information than they had ever had before. Yet, at the same time, it set a terrible trap – inertia and its concomitant – the inability to influence or alter.

Arguably, the horrors perpetrated during the second half of the twentieth century are more shocking than those of the 1914–18 War, but no longer are they reported primarily through the written word – an instrument that allows *participation* in the

unravelling of events. Instead, radio and then television have got there first, and, in the case of television its audience has been bombarded with an indigestible succession of reports. This rapid method of communication is so bewildering that people have recoiled from its insistence, dismissing much of what it has to tell as swiftly as it itself moves on to the next story: the more limited a person's involvement in any event the greater their feelings of futility and helplessness.

In his life and in his painting Francis Bacon both lived out and analysed this predicament. His racy, hedonistic existence complemented his disbelief in the significance Christianity gives to life: "When I'm dead, put me in a plastic bag and throw me in the gutter".[18] His work continues to be a permanent reminder of man's new experience of total impotence. But how have other British artists reacted in their portrait paintings to the alterations in the consciousness of the Nation's psyche? Already, by 1913, Charles Péguy had observed that "the world has changed less since the time of Jesus Christ than it has in the last thirty years".[19] How cataclysmic the remainder of the century has been by comparison, and especially to those already alive in 1900! Yet, in the face of so much utter horror, it is astonishing to observe how some excellent artists have chosen in their work to ignore the inner desolation of it all. Take Sir John Lavery (1856–1941) and Dame Laura Knight (1877–1970), both of whom experienced aspects of warfare and man's inhumanity to man at first hand. Significantly both of them had had difficult childhoods from which they emerged with energy and ambition, shutting their minds to unpleasant memories. Both could be described as good reporters able to depict a scene accurately and with interest, but neither portrayed their sitters in a revealing manner. Lavery occupied himself with painting social butterflies – all "wriggle and chiffon" was how Sickert put it while Dame Laura enjoyed drama and boisterousness in her pictures of ballerinas and circus performers. When it came to war-time Lavery painted the Fleet leaving Scapa Flow in 1917 with great precision and visual beauty, discounting the uncertainty and fear of the times. Laura Knight, the modern woman, who asserted "I paint Today", got no further in her penetration of the character of Ruby Loftus screwing a breech-ring in 1943 (see p. 50) than an advertisement would have done.[20] But Lavery was knighted and Laura Knight created a Dame Commander of the Order of the British Empire: both were undemandingly popular. Nearer our times an artist whose portraits also appeal to a fashionable clique, but not to the heart, is Tom Phillips (b. 1937). His sitters chillingly acknowledge late twentieth-century life in their dress and pose; yet they are presented in a precious, intellectual and esoteric manner. Each of these artists appear to have lacked almost totally that empathy without which no portraitist can be truly great. Nevertheless, as painters, they are considerably better than those who simply set out to give their sitters everything they wanted: smart angles, smart clothes and professional aplomb.

But if Lavery, Knight and Phillips have, for various reasons, ignored the great changes that have affected people's consciousnesses and thus their mien, Sir William Orpen (1878–1931) took a slightly less superficial course in his paintings. Though guarded in his self-portraits – where he showed himself wearing a mask or as the observing artist – and preferring in his correspondence to discuss people's looks rather than their thoughts or emotions, he could be a passionate artist. This is particularly evident in his canvases of the 'frocks' at the 1919 Peace Conference – large set-pieces injected with a bitter irony – and it is apparent to a lesser extent in early portraits of working women and in his studies

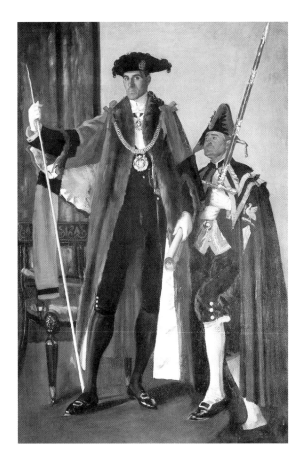

of Tommies in the trenches.[21] However, when he was divorced from these stimulii and faced with daily needs he returned to a style which matched the slick fashions of the time and which served him well: by the 1920s he had become a millionaire.

Compared with these artists, Augustus John (1878–1961) had little interest in establishing himself among the affluent by stroking their self-esteem. Moreover, a nodding awareness of changing sensibilities is hinted at in his work, though his ego was too overwhelming for this to be sustained. In 1907 *The Times* spoke of "his very advanced and modern methods" and of his interest "in the realities of life, the ugly as well as the beautiful".[22] This is born out in his flatly modelled, cut-out figures, but his sense of the "realities of life" is rarely sharp enough to startle, and, nearly always, his portraits speak of his own persona: the unconventional, uncertain, dashing character – one who lacks an inner toughness. Ideally he needed always to have people around him who could fire his imagination, thus fellow-artists, writers, eccentrics and the women with whom he was currently obsessed were his chosen companions and sitters. When he became bored he painted badly or abandoned his subject altogether. He was a legend for his outrageous life-style and magical draughtsmanship – in the minds of many the epitome of the modern portrait painter. However, he was no Philip de Laszlo – the doyen of Royalty and manufacturer of forty portraits in a good year. Rather he grumbled at painting stupid millionaires and was viewed with suspicion by the straight-laced. He sent a frisson down the backs of the Bright Young Things but led Field Marshal Montgomery in 1944 to ask: "Who is this chap? He drinks, he's dirty, and I know there are women in the background."[23] What is more, if Montgomery had met him earlier in his career he would

have agreed that what was most modern about John's approach to portraiture was his cheekiness. From the point of view of his conservative critics the artist cocked a snook at the status quo, as can be seen in his portrait of Chaloner Dowdall Lord Mayor of Liverpool (1907), whom he has made into a Velasquez gallant accompanied by his dwarf (III).

Augustus John was a character but his self-centredness and artistic limitations – he could draw but not paint well – did not enable him to create many memorable characters on canvas; perhaps his picture of the painter Matthew Smith, an old friend, was one of a handful of successess.[24]

If John responded to vivacity so did John Singer Sargent (1856–1925), but in his perception of his sitter's character Sargent probes the deeper. Moreover, although he was a generation older, there are aspects of Sargent's work that, paradoxically, herald the dawning of the modern consciousness in a way that John's does not, making the latter appear, by comparison, old-fashioned. During his early career in Paris Sargent painted portraits of outstanding originality, though after the scandal caused by the exhibition at the Salon of his portrait of *Madame Gautreau* (1884) it was admitted that "women are afraid lest he made them too eccentric looking."[25] Notwithstanding this his friends and women of pronounced character always warmed to his courageous approach. He enjoyed living in an intellectual milieu and cosmopolitan determination engaged his talents more fully than the brittle British upper-classes whom it was his fate to depict during the Edwardian heyday.

Emerging sometimes from Augustus John's canvases, though more pronouncedly from those by Sargent, is a direct interest in the sitter's personality unswayed by social or even artistic conventions. Yet if Sargent perceived and rendered the inward self of his sitter with a decisiveness that sets him above such painters as Laura Knight, Lavery, John, Orpen and Phillips, even his penetration appears cursory when compared with the concentrated insight of Sir William Nicholson (1872–1949). From the moment the public's attention was captured by his woodcut of *Queen Victoria* (1897) it was seen that, if left to paint whom he chose, Nicholson would respond to the uniqueness in a personality (IV). He preferred the very young or the very old to be his sitters for both are, usually, indifferent to flattery and remain themselves. He also belied Alexander Pope's contention that women are without character: two of his subjects, Queen Victoria and Gertrude Jekyll (painted by him in 1920), were women of formidable energy and achievement to

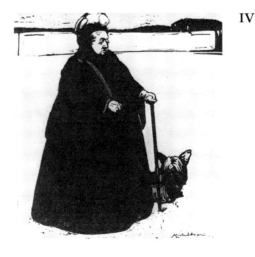

IV

whom he did full justice (see p. 31). By doing so he was acknowledging, albeit subliminally, women's increasing prominence in public life.

Anyone of discernment wishing to have their portrait painted before 1914 would think of Lavery, Orpen, Sargent and possibly, if they could engage their interest, Nicholson or John, as well-established 'names'. These artists understood the requirements and pit-falls of portrait commission and avoided it, or not, as the case might be. If they embarked upon a commission they were expected, by their clients, to produce a fine picture and to remember to curb any controversial inclinations. However, one of their contemporaries, Walter Sickert, refused for many years ever to bow to this treadmill, preferring to paint "the people of the dustbin rather than the pearl-fettered lay figures and images, embalmed and enamelled, of the drawing-room".[26] In 1910 he wrote: "The best portrait is, I should say, the canvas that would give the spectator the truest idea of the physique, and through the physique, of the character of the sitter" for Sickert, true to his original calling as an actor, was fascinated by what humanity suggested.[27] Indeed, in his pictures of charwomen, milliners, performers, artists, writers and friends the sitters do not simply display themselves – they live. His was a truly modern attitude, daring for the period, but as he seldom sought clients he was undeterred. By 1925, within the context of the Royal Academy Summer Exhibition, his portrait of *Victor Lecourt* was still considered somewhat avant-garde (V). Its rough, unvarnished surface, its informality and lack of detail, and the fact that Lecourt was a mere restaurateur, made it clash with the plethora of society portraits – so "insipid and without character" – also on show.[28]

Of the most significant artists who turned their hands to portraiture in the early years of this century both Sargent and Sickert were, in many respects, outsiders: the one a Jamesian American, the other by instinct a cosmopolitan European. Into a similar category

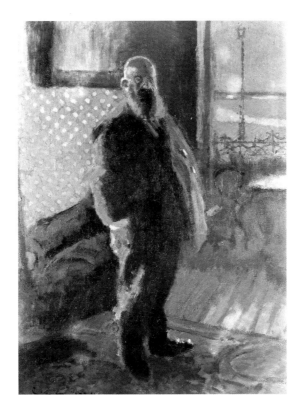

V

must fall the Jewish painter, Mark Gertler (1891–1939), brought up in a Yiddish-speaking household in Whitechapel. At times, all three of these very intelligent men brought to their portraits a disinterested toughness not seen in the run-of-the-mill practitioners of the genre. Gertler's talents and insight were extraordinary. A child of the ghetto, untutored as yet in British culture, but intimately aware of "the hardness of existence", he took the Slade School of Art by storm, exciting them as much as had his predecessors Orpen and John.[29] In 1910 he won the Slade's portrait prize and the following year his picture of Golda Gertler, *The Artist's Mother*, was bought by the well-known collector Sir Michael Sadler. In fact, aged twenty, "he had everything that an artist needs to gain him a baronetcy and a dignified mansion in the Home Counties".[30] Yet, though his engaging personality brought him an extraordinarily glittering circle of friends who, in a sense, pulled him away from his roots, those roots were deeply tangled in his psyche. His moods, like his painting style, were always mercurial; this changeability was brought about by his manic depression and his total honesty. Both characteristics sprang, in part, from his inheritance – he always considered himself as an outcast. This perception of himself led one of his patrons to describe him as "infinitely greater and deeper in your moods than any Englishman I have met . . . ".[31] By 1914 Gertler, in his thinking, was beyond wanting to be a drawing-room painter. Indeed, his portraits to date had been characterised by a searching, grown-up quality – remarkable in someone so young – the production of a sensibility nurtured on the sorrows and dilemmas of life. Not surprisingly, he declared himself a pacifist at the outbreak of war. Even so, and although he did not experience the horror and degradation of trench warfare, he described the manifestations of mental suffering as aptly as any soldier condemned to treatment in Craiglockart Hospital: (it is) "like a disease," he wrote, "When in such a state I lose all control of my harmony. It's a sort of madness."[32] This disarming frankness was, in some respects, unusual for the time though, as private diaries and letters have since demonstrated, the stiff Victorian upper-lip was beginning to tremble: people were daring to write and sometimes to speak of their innermost concerns.

Two portraits completed in the months before the war reached its terrible climax go to the heart of Edwardian complacency and act as precursors to the new ways of thinking that would unfold in the years ahead. Henry Lamb's painting of *Lytton Strachey* (1914) and Vanessa Bell's of *Mrs St John Hutchinson* (1915) act as beacons of criticism – warnings of the overwhelming disenchantment felt by the younger generation towards their elders, each picture affirming in an oblique manner a need to express unuttered truths. Neither is a 'war' painting: in each the painter appears self-assured, yet each reveals how radically the old framework of certainties is being dismantled by the presence of the new uneasy questions – what are we? why are we? These two portraits probe the inner life of the sitter, they expose the painters' own emotions and they disregard the orthodox uses of paint and the conventional formulas for portraiture in their determination to make the surface yield what lies under it.

Lamb's extraordinary canvas in which his sitter is placed before an over-sized window, reflects perhaps the gales of fresh air that were to change the art of biography for ever in Lytton Strachey's masterpiece *Eminent Victorians*. As Henry Lamb (1883–1960) painted Strachey wrote, working up a series of pithy portraits of Victorian worthies some of whom he admired, others whom he did not. The two men had long been sparring partners; Lamb was well-read, and Strachey gave him part of his manuscript to criticise.

When the book was conceived the writer had intended his subjects to be seen "from a slightly cynical point of view" but when Lamb read the piece on Cardinal Manning in 1915 he felt it to be very strong indeed.[33] By then Strachey had espoused pacifism and as the war progressed he became determined to expose the grand old men of the Establishment whose inherited values had brought the country to its knees. The book was published in May 1918 and its method of "sapping innuendo and . . . carefully placed explosive epigram" damned nineteenth-century hagiography for ever.[34] By the standards of the times Henry Lamb's portrait of its flamboyantly outspoken author, though a credible likeness, was odd, and daring too (see p. 15). It did not flatter: nor is it a caricature being, with its multitude of metaphors, too elaborately suggestive of its sitter's concerns and opinions for that. Neither is the painting entirely artificial for its metaphoric content is unlike anything seen in earlier portraiture where such adjuncts are part of the sitters' public personality. Here, Henry Lamb is concerned with Strachey's soul: he has painted a portrait of a highly sensitive man – an idiosyncratic intellectual. But, as a mutual friend, Lady Ottoline Morrell noted, his was a character in which high seriousness was spiced with femininity. This was just another way of explaining Strachey's homosexuality, which can be deduced from the set of the body, the slant of the legs, and from the inclusion of a basket chair draped with a cosy rug – not, surely, the usual trappings of a man still in his thirties. The hat and umbrella, though part of male attire, would, undoubtedly, have been worn by Strachey with a waspish flourish and their presence echoes his satiric turn of phrase. The small figures in the background have not been positively identified but, seen walking away through the shut window, it seems as if Strachey has dismissed them with the stroke of his pen.

From the public's point of view, Lytton Strachey was dangerously bohemian, but, even if in those more innocent times their analysis stopped there, his writings were exceedingly forward. Stephen Spender, recalling his father's utter horror at the modernity of the painting remembered how this reaction was swiftly followed by recollection: here was the villain who had written so disrespectfully on five eminent Victorians. "Well," the old man said, "Lytton Strachey deserves it! He deserves it!"[35]

Edwardian etiquette was rigorous in its requirements and Lamb's sizeable statement in oil paint concerning a man of strange views might well have shocked not just old Mr Spender but a wider audience if it had been seen in 1914. Already, Roger Fry's two Post-Impressionist exhibitions of 1910 and 1912 – in which many of the painters had applied their paint with an astonishing freedom – had considerably shaken people: Edwardian values seemed to be being thrown to the winds. But Fry did have his adherents too – most especially the artist Vanessa Bell – who would eagerly exploit this new freedom of expression.

Vanessa Bell (1879–1961) always disliked the purely literal approach to painting and once wrote tartly that her parents-in-law's collection of family portraits were "done from photographs by the photographer I should think".[36] She preferred the ideas being promulgated by her husband Clive Bell and the art historian Roger Fry. Taking the Post-Impressionists and their successors as their points of reference they suggested a fresh look at the world, one in which the human figure – with its gestures, gait and colouring – was distorted and abstracted thereby allowing art to produce an equivalent to, rather than a reproduction of, life. In 1914 Fry was invited to write a book explaining his theories but, because of pressure of work, he delegated the task to Clive Bell. However, he acted as

consultant and Vanessa, always present during their conversations, later read the manuscript and corrected the proofs. The writing of *Art* encouraged her to experiment still further in her own picture-making and between the Post-Impressionist exhibitions, and 1918 she produced some of her most adventurous work. This included her portrait of *Mrs St John Hutchinson*, an avant-garde presentation of a chic young woman (see p. 19). In the picture Vanessa Bell practised the art of leaving out superfluous detail, something which her sister, Virginia Woolf, also learned from Roger Fry, as she explained in her biography of him. "Literature was suffering from a plethora of old clothes. Cézanne and Picasso had shown the way; writers should fling representation to the winds and follow suit."[37] But there is another element present in Vanessa's portrait – the personal. Uncontrolled pique at the knowledge of Clive Bell's affair with Mary Hutchinson has resulted in an unnecessarily savage distortion to the face. Never again did Vanessa reveal her emotional state in paint for, as her sister remarked, she was usually expert at concealing her thoughts albeit behind an "extraordinary look of anguish, dumb, not complaining".[38] In its way, this is a small indication of the gulf opening up in the early 1900s "between respectable mum(m)ified humbug and life crude and impertinent perhaps, but living".[39] In the future not only would artists be prepared to show the inwardness of their sitters but they would show their own emotions too. The old framework was giving way to a new freedom, but this freedom produced stresses and risks not previously encountered.

In the 1890s it was unimaginable for a woman from a respectable home to paint her husband's mistress: a generation later Vanessa Bell did so. Neither would anyone have believed that a young woman artist could support herself alone in Paris while having a passionate affair with the ageing but licentious sculptor Auguste Rodin: Gwen John was she. But having to cope with the consequences of their actions was another matter. There exists a *Self-Portrait* of Gwen John (1876–1939), painted when she was in her early twenties, hand on hip, assertive of gaze, capable, attractive – the epitome of the 'new woman'[40] (VI). It seems the world is all before her yet, already, she had born much. She had quarrelled with her father, who had accused her of dressing like a prostitute and, as a

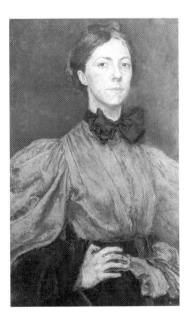

VI

consequence, she had refused to accept an allowance from him and was living in penury. Worst of all, she had been jilted by the painter Ambrose McEvoy. But, as can be seen in the portrait, Gwen John possessed an intuitive resilience. She confronted life with spirit, and her sitters with a penetrating and – as in her portraits of Dorelia McNeill – tender insight. But there was nothing in the world she had left, nor yet in the new emancipation she had seized upon, that could tell her how to cope with her obsessive attachment to Rodin. Wholly alone in a situation undreamed of by her respectable predecessors, without reference or guidance, she was reduced to a trembling recluse. By 1909 the affair, in which Gwen gave all and Rodin little, was at a pitch and she was aware of its debilitating effects upon her. She pined and grew thin; she developed migraines which she knew to be psychosomatic. Her pride and her depression allowed her but to turn inwards. She was the 'new woman' in name only, lacking the equipment of her late twentieth-century equivalent for survival. Her changing mental circumstances are charted in the portraits of women she painted from 1904 – the year in which she met Rodin – until the end of the decade. Innocence is replaced by wariness, sadness, even bitterness – each sitter somehow reflecting an aspect of Gwen's struggle to exist in a situation where all familiar references have been abandoned leaving behind them nothing but a native instinct.

Gwen John possessed a high degree of pride which forced her to retire into obscurity when life's pressures became too severe. By this time her illusions had been shattered. A generation later Stanley Spencer (1891–1959) also faced a grave emotional crisis. Yet, because of a native innocence which never deserted him he, unlike Gwen, retained his illusions: they would serve him ill in his life but well in his art.

In many respects Stanley Spencer was untouched by the opinions and values of his time, not because he believed in lawlessness or because he wished to reform the world, but because he felt that his personal world was completely normal. His vision was extraordinarily original, charged with this astonishing innocence and with an incredible honesty. In character he oscillated between the saintly and the bellicose but his curious and fertile mind drew people to him who, in times of need, were his emotional bedrock. In the 1930s he was lured into a peculiar sexual relationship, and marriage, with Patricia Preece and the portraits resulting from their liaison are a novel contribution to the history of British art, and a rare example of his disillusionment with life. Taken at face value they seem, even now, outstandingly erotic. As he wrote in his Daybook during 1938: "I am convinced the erotic side I am drawn to belongs to the very essence of religion."[41] Familiar with the Bible since childhood and believing, like St Augustine, that the ordinary was charged with the spiritual, he habitually interwove the sacred and the profane in his paintings – an interweaving that has preoccupied artists since classical times – though no artist before the twentieth century did so with such overt and devastatingly frank personal reference. His approach when painting Patricia goes further still involving, albeit at a subconscious level, the psychoanalysts' methodology of self-examination. It is not surprising that a few years later he became a close friend of the Jungian Charlotte Murray.

Stanley Spencer and Gwen John both exhibit a new kind of inward scrutiny in their portraits of themselves and their familiars, one in which the individual is shown shorn of any persona and exposed, mentally naked, to the modern world. Since the 1960s presentations of sexual loneliness have been expanded further by David Hockney (b. 1937) who, together with Francis Bacon, has dared to introduce the art-loving public to

the hazards, rejections and betrayals of homosexual love. In such paintings and drawings Hockney presents a certain coldness of mood and exhibits a shut-off attitude to sex. He seems to compartmentalise it in an uneasy manner which is paralleled only by the Victorians – perhaps because, in the 1960s, homosexuality was still a vexed subject. But, if at times displays of coldness are evident in his work, Hockney is never impersonal. In his pictures of individuals with whom he has had no sexual involvement, or in those of his little dog, he is objective and intuitive – utterly tender and full of charm. 'Impersonal' is, however, an adjective that goes some way towards describing the portraits painted by Francis Bacon and Frank Auerbach. Both of these artists have taken portraiture to the extreme – their subjects' faces are usually most difficult to interpret as such – and it is tempting to ask why they paint the human figure at all. Yet each of them has spoken passionately about their commitment to the practice, and each of them sees it as the ultimate challenge of their career.

For Francis Bacon a mere colour photograph of a likeness was an unbelievably boring approach to portraiture because when painting he wished to convey the "pulsations of a person", their "emanation".[42] 'Pulsations' is the key word: there is no suggestion of permanence or a stable identity in these portraits usually they reveal, after serious scrutiny, suggestions of character, while rescued from their twisted features are recognisable elements of each individual. The sitters are people Bacon knew intimately, people whom he tested to the extreme in his knowledge of them and the translation of that knowledge into paint. Yet it is impossible to communicate with the sitters across the painted surface, to know much about them as people, instead there is a general impression of their struggle for existence in the twentieth century. Much stronger is the impression of the artist's own sense of the futility of that struggle – the pathetic and ineffectual suffering it involves, and his total rejection of the possibility that there might be anything enduring in the human soul, or any meaning in its plight.

A superficial glance might suggest a similarly bleak view of the human condition in the work of Frank Auerbach (b. 1931). At first sight, and in the wrong light, all that can be seen of a Frank Auerbach portrait is thick whorls of paint, but then comes the thrilling realisation of a face, and a face that looms, so to speak, out of the darkness. Auerbach is an artist with a marvellous control of his media – paint and drawing materials. He has a well-developed understanding of the human body. Rather in the way that J. M. W. Turner took liberties with the landscape, having first understood the laws that govern it, so Auerbach takes liberties with the face. His portraiture is devoted to the painting of a few intimates, those prepared to be patient with the many sittings needed to achieve his aims. Knitted into his psyche is a need for the familiar, the secure – a need coming, partially, from his experiences as a Jew in Nazi Germany. He owes a debt too to David Bomberg, his tutor at the Borough Polytechnic, for making him look beyond just the shape of the person or thing he was depicting to its heart. The result is a very personal manner of explaining a sitter – eyes, ears, mouth, the usual expectations of a portrait, are unclear: they are identified in a sort of shorthand composed of carefully judged flicks of paint.

On the face of it both Bacon and Auerbach's kind of portraiture is difficult to explain. The reverse could be said to be the case with Lucian Freud (b. 1922) yet he, too, has a particular point of view to convey. Like the others, people's airs and graces are ignored and, like them, he prefers to know his subjects well so that he can call upon their

indulgence for sittings. His portraits though are of people with easily decipherable heads and bodies whose feelings and predicaments can, at times, be strongly present. But frequently he, too, breaks new ground. He is fascinated by the history of the entire body, wanting to get inside people's beings, in the way an actor would, to see how they appear in their moments of privacy. This means that he regularly paints portraits of the naked body showing his sitters in a completely relaxed and uncontrived position, thus firmly distinguishing the meaning of 'naked' from 'nude'. At first glance it seems as if Freud is a misogynist. But he is not, rather he approaches the naked female body with total openness in order to catalogue its ugly corners – usually filling the canvas with it at the expense of the head – because, for him, it is so expressive of the whole person.

Freud, Bacon and Auerbach are painters who do not wish to have any relations with their subjects while they are painting them although all of them know their sitters' minds and bodies well. They are therefore engaged in a very novel kind of portraiture, one which is totally private, and which translates less easily for the ordinary spectator. Standing in front of one of their portraits a very different set of questions needs to be asked by the viewer than those that would be posed before a portrait by John Singer Sargent. Even more, the spectator is aware that that untroubled synthesis of the human heart and the artist's eye, from which a Rembrandt created his portraits, is not present here.

It can be argued that Gwen John and Stanley Spencer's emotionally haunted faces, David Hockney's restlessly roaming homosexuals, and the somewhat 'impersonal' portraits painted by Bacon, Auerbach and Freud, are the result of these artists trying to ease their own sense of the nature of life. Often they, and not their sitter, become the personality: self-exposure evolving dangerously into self-indulgence and thus limiting the work, as happens in Paula Rego's portrait of *Germaine Greer*, although here it is the impact between artist and sitter of fiercely-held feminist convictions that blocks perception. In contrast, John Bellany's early portraits, and those by Graham Sutherland and Maggi Hambling, stand apart: these artists are not so busy telling the spectator what they feel about their lives for they have achieved that synthesis of the artist's eye and the comprehending heart.

John Bellany (b. 1942) had an 'idyllic' childhood spent with a close-knit family in a Scottish fishing community whose patterns of existence had remained essentially unchanged for centuries. It was an extraordinary environment – God-fearing, superstitious, almost mediaeval in outlook – and one strongly sustained by the Calvinist faith and by the recognition that death at sea was an ever-present threat. These roots acted as a powerful stimulant to Bellany's imagination, which developed and prospered, enabling him to produce paintings of high seriousness while still an art student. Always they are more-or-less autobiographical, with the artist casting himself in the role of narrator. But, as over time he disengaged himself from his roots, the intensity of feeling and the challenge to thought began to wither, to be replaced by personal idiosyncrasy. It seems that, thrown by accident of birth into a strangely atavistic society, he floundered once its embrace slackened. Perhaps he could be said to illuminate the fate of the modern consciousness which, when it is not supported by a firm cultural structure, becomes irresolute. This loss of a cultural crutch has meant that, ironically, Bellany has changed roles and taken his place alongside many of the sitters in the portraits considered here. In doing so he, and they, suggest another distinction which throws light on one of the major social changes of this century – the position of women. Nearly always, when the sitters

are men they appear to rely on whatever crutch is provided by the outside world. If that crutch is absent, as in so many of Francis Bacon's portraits and in John Bellamy's work once he abandoned his roots, the subject disintegrates. When the sitter is a woman, however, there is less sense of an invaded and scattered identity. Even Stella West (E.O.W.) in Auerbach's many portraits of her pulls together the apparently random brushstrokes to give herself being while the women painted by Gwen John, Vanessa Bell, Gertler, Rego and others may be only partially perceived, but their identity is not threatened.

The greatest painters are aware of this distinction but it never distorts their perception. Unlike John Bellamy, both Graham Sutherland (1903–80) during his lifetime, and Maggi Hambling (b. 1945), have produced work which has always been informed by an inborn sense of the divine. In their different ways each of them has been open to the patterns and wonders of life, sensitive to – and wishing to make sense of – all its nuances. Sutherland's anthropomorphic landscapes – "reality told in a different way" – led on to his vivid portrayals of old age, his storm-tossed faces as full of potent possibilities as were his *objets trouvés*.[43] Usually both he and Maggi Hambling have been choosy about their sitters, wanting always to be interested in them and moved by them. In their work they have teetered on the edge of abstraction, not in order to be doctrinaire, but so as to understand better the shape of life. For Hambling it has involved, for example, a serious study of how and why people laugh, her draughtswoman's eye allowing her to exploit wonderfully the chance effects of the runny watercolour that she uses to create the fleeting movements of this phenomenon.

In a world of instant communications, speed, and the moving picture – where we, seemingly know everything in a moment – the portraits painted by Graham Sutherland and Maggi Hambling throw into thankful relief the tradition of great portraiture which stretches back to the Renaissance. Painstakingly, and with their artist's eye, they have seen what we normally overlook in our quest for instantaneity, and they have done so in a manner which reflects both that past and the modern consciousness.

Graham Sutherland did not start painting portraits until 1949 when he was aged forty-six and already an acclaimed landscapist. He did so by way of a challenge, telling his first sitter, W. Somerset Maugham, that "if it can be regarded purely as an experiment I would very much like to try".[44] At that time portrait painting in Britain was at a low ebb and the public's critical faculties – if not those of all professional art critics – attuned to the somewhat conventional representations favoured by the outgoing President of the Royal Academy of Art, Sir Alfred Munnings. Sutherland's early faces therefore provoked strong reactions: they were so very different from those painted by 'society' portraitists such as Munnings himself, Sir Gerald Kelly, A. K. Lawrence or Edward Halliday.

Three of his portraits completed in the years surrounding the Churchill commission (1954) illuminate well the way in which the artist helped change people's attitudes to how they could look on canvas. Each in its way is a 'first' in the genre: in 1949 he entered the field with his portrait of Somerset Maugham; in 1955 he painted his first friend, Edward Sackville-West; and in 1957 he depicted his first woman sitter, Helena Rubinstein. Initially Sutherland's interpretations astonished them all but once they had had time to digest what he seemed to be saying they came to admire his penetrating appraisals of their characters.

Take Somerset Maugham for example: according to Graham Sutherland he

"blanched"[45] as his picture was unveiled but, after considering it, agreed that it was "magnificent" adding, "There is no doubt that Graham has painted me with an expression I sometimes have, even without being aware of it"[46] (VII). Certainly the artist was gifted with great insight into character and had discovered how greatly his sitter disliked psychological probing, fearful of having his private affairs and his homosexuality revealed to an unsympathetic world. Because of this Maugham had, as a young man, donned cynical and sardonic armoury beneath which, as Sutherland and others had discovered, lay a measure of generosity and kindness. It is not surprising therefore that he should have responded with shock and then magnanimity to this picture and his comments, surely, indicate something of the strain he must have felt at wearing his world-weary mask.

To paint a close friend, as Sutherland undoubtedly would have realised, is as much a challenge as to paint a stranger for friendships make allowances for weaknesses in character which a good portrait cannot do. However, Edward Sackville-West had, in 1943, written a particularly perceptive book on Graham Sutherland's art in which he had described his landscape paintings as portraits, "though his portraits are of tree-trunks, of grass-blades, of huge hemlock flowers, of old stones, rather than of human faces or arrangements of books and fruit".[47] Thus Sackville-West would have expected close scrutiny as he sat for his own 'likeness' (VIII). When he saw it his reaction was enthusiastic and candid. He felt the portrait to be brilliant; Sutherland had "found him out" for it is "the portrait of a very frightened man".[48] Though delighted, the artist

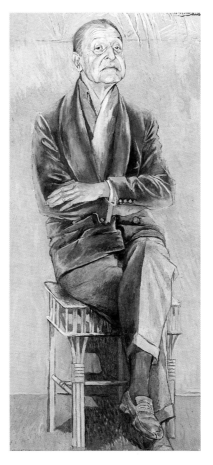

VII

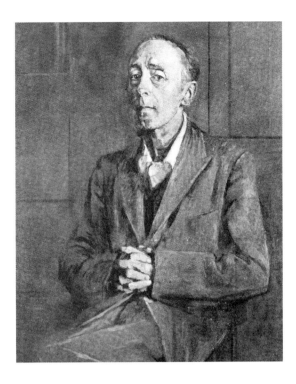

replied saying that he had seen his friend as tense, shy at being scrutinised so closely, slightly mocking, detached, poised and critical – even tired of life.[49] Their correspondence makes an interesting reflection on the portrait for though Sutherland appreciated his sitter's nervousness he had not, intellectually, pinned it down as fear, though the ghost of that fear must have, intuitively, informed his pencil and brush. This is an example of an artist giving himself over completely to what lies before his eyes and not allowing his own personality to interfere with the evidence.

Initially Helena Rubinstein's reaction to Graham Sutherland's exposition of her character was one of great dislike – "I had never seen myself in such a harsh light" – but it later changed to admiration and she came to describe the picture as a "masterpiece"[50] (IX). She was a tough sitter, a domineering octogenarian businesswoman who knew how to cower and cajole people for her own ends. Sutherland has painted her with truth, admiration and tact, taking advantage of her love of exotic clothes and jewellery to envisage her as the empress of – naturally – her cosmetic business. Tactfully he has noted, but not over-emphasised, her thinning hair, while detailing her skilful application of make-up which was, she always insisted, a woman's passport to an eternally youthful face. Viewed from below her tiny figure acquires both regality and dominance, the latter a reminder of the rule of iron imposed by her upon her employees. All in all, the artist has worked in a similar manner to that practised in his landscape painting – he has seen the significance beneath the outer being.

Between them these three sitters possessed intellectual abilities and great drive and, in their various ways, they did not suffer fools gladly. To have responded as they did to their portraits – which they knew to be bold and startlingly original – shows an enormous respect for Graham Sutherland and a realisation that though he may have disclosed uneasy truths about them he did so with the utmost seriousness and sincerity. However, some of his other portraits caused great and permanent discomforture – most notably that of Sir

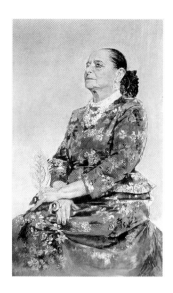

Winston Churchill – which was not Sutherland's intention, though he feared that some sitters' expectations were confused by the prevalence of photography, which had made them "superficially" aware of what they looked like and of how they wanted to be portrayed.[51]

In order to fully appreciate the events behind the painting of a portrait it benefits to have as much information as possible about the artist, the sitter and the reasons why the portrait was painted. In the case of Graham Sutherland this knowledge is fairly easy to come by for both he and a number of his sitters are now dead. Assessing the merits of a living artist is a more delicate affair for things cannot always be said and people can be offended unintentionally. Therefore a comparison between Sutherland's portrait practice and that of Maggi Hambling can only be tentative.

Quite obviously Hambling enjoys people – and from all walks of life. In the twenty or so years during which she has practised portraiture the range of her sitters has been broad – boxers, musicians, comic actors, lawyers, academics, scientists – all have passed before her eyes. In some respects these people look less hierarchical than Sutherland's sitters, possibly because the settings are less rigidly geometric and more painterly. But since the 1940s, when Sutherland began portraiture, and the 1970s, when Hambling did so, life has taken on a considerably more informal manner and, consequently, people have, little by little, adopted more relaxed gestures and adhered to a less strict code of dress. Nevertheless it takes very little prompting to guess at her sitters' walks of life for Hambling's eyes, like Sutherland's, acquaint themselves fully with each person's particular 'humour' together with their persona. However, it goes further than that for, like him, she sees each individual's degree of seriousness and personal concern. For example, her portrait of the blind boxer *Charlie Abrew* (1974) gives his hands and face equal prominence. They were the 'weapons' of his profession, now ended, and yet how respectful he remains towards them, drawing attention to them by surrounding them with a jazzy shirt and a smart suit (X). This is a marvellously poignant study of how a man has risen above his tragic loss of sight. Again and again, a close examination of Hambling's portraiture exhibits a series of inner resonances which she has, intuitively, been guided to by her penetrating eye – something which links her closely to Graham Sutherland.

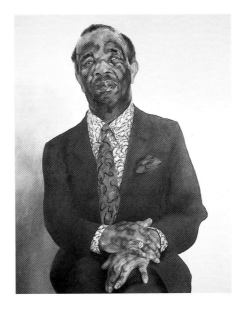

X

It has often been said that Sargent was the last portrait painter of any significance working in Britain and that, in any case, portraiture is dead. This book has set out to demonstrate that portrait painting is alive and well, maybe because none of the artists discussed here have been shackled to it throughout their careers. Even Lavery and Orpen, who got dangerously close to being so, were aware of the perils and cast around for diversionary subject-matter. But questions need to be asked: what do portraits contain that an excellent photograph does not, and indeed why, in an age of sophisticated photographic equipment, do artists bother to paint them? The camera's eye and the human eye see their subject differently, the monocular vision of the former being circumscribed by time and by a lack of intelligence, whereas the informed, binocular eye carries with it all the imagination and experience that go towards making the best artists' portraits things of infinite value.[52] In that each of us – though possessed of a mouth, a nose and two eyes – is subtly different from our fellows, so each artist who attempts a portrait of a particular sitter will see that particular sitter differently. Portraits are therefore not predictable, it is always a question of the point of view informing them. Conversely a row of photographers photographing the same person at the same moment will produce more or less identical images. To be specific, how could a camera have composed Helena Rubinstein's figure as Graham Sutherland has? It could not have orchestrated her dominance, Sutherland's admiration for her, and the adroitness with which he has played down her baldness and her sagging jaw while, at the same time, highlighting, with understanding, the expert manner with which she has applied mascara to the crow's foot spreading from the corner of her left eye. To look further, how could a camera have suggested the textured blue background to Maggi Hambling's portrait of Judge Stephen Tumim (1992) with its suggestive possibilities? (XI). Is it a dank, stone prison wall? Is it expressive of the sky and expansiveness, thus a symbol for the greater advantages the Judge wished prisoners to have in order to aid their rehabilitation? And what about her style of painting his striped shirt – could not the wavy lines denote Tumim's imaginative, dexterous mind? Risky speculations perhaps, but the point is that a camera is totally unemphatic and without the artist's imagination, whereas portraiture can be the ultimate artistic challenge drawing painters to it as to a magnet. But to understand and unravel a

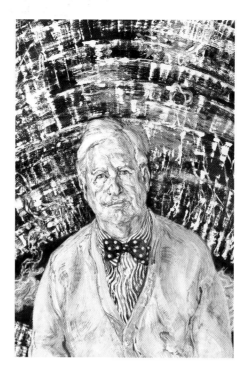

sitter's life history in paint is not an easy task and a prerequisite for its success is a fascination with – even a love for – people. In addition, the artist's active imagination and analytical mind are essentials. Obvious as this may be it does not, however, explain why some portraits strike us as great ones while others do not, but it does provide the basis for an answer to this ultimate question.

The rapid changes in the nation's consciousness that have characterised the twentieth century in Britain are, from the artist's point of view, hinted at in Oscar Wilde's *The Portrait of Dorian Gray* (1891): "every portrait that is painted with feeling is a portrait of the artist, not of the sitter. The sitter is merely the accident, the occasion . . . it is rather the painter who, on the coloured canvas reveals himself".[53]

However, as has been argued, not all of the portraitists discussed in this book fall into Wilde's category of the 'confessional' painter. What Wilde describes is – although he may not have realised it – a limitation. True universality, and therefore true greatness, lie beyond the reach of the 'confessional' painter. Many of the artists discussed in this book fall into his category: but not all of them. At times the paintings of William Nicholson, of Sickert and, more specifically, those of Sutherland and Hambling, achieve a distinction of a higher order. Common to this group of artists is a respect for, and a curiosity about, their sitters, allied to which there is an ability to pick out those essential details which allow their subjects to 'live' on the canvas. They exhibit also a generosity and a magnanimity in their interpretation of character, thus avoiding the shallow scrutiny of a Lavery or a Phillips who never advance beyond the niceties of the tea-table. However, Sickert fails to meet the criteria of greatness in his portraits on two counts: in the first instance the actor in him shines through too often, allowing him to 'use' his sitters instead of exposing the whole of himself to their characters. This is particularly noticeable in the many female portraits painted by him during the 1890s and 1900s when they are seen in a situation, not in their specific milieu. There is, too, a faint air of detachment in his later

work where he often used photographs as a starting point: the photograph creates a filter as, for example, in his painting of Hugh Walpole, now in Glasgow (see p. 41). On the other hand, William Nicholson's work comes closer to Kenneth Clark's definition of great portraiture as the "record of an individual soul" though, too often, Nicholson had to paint people merely to top up his income.[54] It is also apparent that he never tackled the greater human emotions – grief, fear, power, endurance – concentrating instead, in his best work, on the quiet subtleties of daily existence.

Unlike Sickert or Nicholson, Graham Sutherland and Maggi Hambling do not seem to have been influenced by the twentieth century's ever-insistent demands, expectations and restraints. Above all they have used their eyes and their intelligence to reveal their sitters' nature and they have not been swayed by adverse reactions to the results. Their approach has been one of openness: they have sought for the essence of a character but they have not judged it. They have been as unprejudiced as Henri Matisse, who once remarked: "Seeing is of itself a creative operation, one that demands effort . . . (the artist) must see all things as if he were seeing them for the first time. All his life he must see as he did when he was a child."[55]

In a sense, his words paraphrase Sutherland's and Hambling's approach to their profession for it is this freshness of vision, a vision filled with wonder and inquiry, which links their portraits – modern as they are – to those painted by Titian, Rembrandt and Van Gogh, great painters who repeatedly grappled with the complexities of the human psyche. Indeed, each of these artists could be described as the most alive person of their generation and among the few, to quote F. R. Leavis's description of the poet, who have realised the "potentialities of human experience".[56] Like the greatest writers their work stands up to close and frequent scrutiny, for the feelings and the actions of their characters are not only common to all time but of their period too. In the sixteenth century, when portraits were essentially still counterfeits, Titian's novel but sympathetic observations of human nature, and his transfiguring use of colour, charmed his royal sitters while detracting attention from his sometimes daring suggestiveness.[57] On the other hand, knowing the Dutch preference for outward reality, Rembrandt turned his psychological inquiry upon himself and produced, over a lifetime, an autobiography of success and suffering as easy to identify with now as it was then. In addition, like Graham Sutherland, he preferred as his sitters people prepared to look themselves in the face without being troubled. Van Gogh strikes yet another timeless cord with his "insight into the wear and tear of life".[58] His modernity of expression and vivid use of colour, coupled with his recognition of suffering, of earnest endeavour, shyness and tentative self-assurance, weave his world and the worlds of Titian and Rembrandt closely to that of Sutherland and Hambling.

The portraits painted by these artists cover a period of four centuries during which mankind has undergone countless mental and physical upheavals and yet, common to them all is a perennial vitality and a permanent relevance. Presentation of character may have changed in emphasis owing to altering social conditions over the centuries, but those qualities in the artist which the critic Herbert Read so admired: "a memory unobscured by prejudice, passion, pride, caution – by half the armoury of the common mind!" remain as constants.[59]

For, eschewing the social, cultural, psychological and spiritual fads and fashions of the moment, the great artist looks, principally, for the uniqueness of the sitter. It is this

human self, modified by the times certainly, but in its essentials always the same, in its individual manifestations always unique, that engages the heart, the mind and the eye of the artist, and which nerves the hand. It is this perception and the certainty with which it is expressed in paint that unites great artists in a single tradition while allowing each to speak directly to their own generation.

NOTES TO CHANGING PERCEPTIONS

1 Alan Bennett, *A Question of Attribution* (French, 1989), p. 50.

2 Michel Leiris, *Francis Bacon* (Thames & Hudson, 1989), p. 18.

3 Stanley Olson, *John Singer Sargent, His Portrait* (Macmillan, 1986), p. 208.

4 *The Magazine of Art* (1901), p. 388.

5 James Morris, *Farewell the Trumpets: An Imperial Retreat* (Penguin, 1979), p. 146.

6 Samuel Hynes, *A War Imagined: The First World War and English Culture* (Pimlico, 1990), p. 111.

7 Ibid., p. 196.

8 'Disabled' from *War Poems and Others* by Wilfred Owen, edited by Dominic Hibberd (Chatto & Windus, 1973), pp. 76–8.

9 Hynes, *A War Imagined*, p. 201.

10 Ibid., p. 307.

11 Angela Holdsworth, *Out of the Doll's House: the Story of Women in the Twentieth Century* (BBC Books, 1988), p. 65.

12 Elizabeth Owen, *Fashion in Photography 1920–1940* (Batsford, 1993), p. 10.

13 Evelyn Waugh, *Vile Bodies* (Penguin, 1938), p. 27.

14 Samuel Hynes, *The Auden Generation: Literature and Politics in England in the 1930s* (Pimlico, 1976), p. 39.

15 'Dulce et Decorum Est' from *War Poems and Others*, p. 79.

16 *To War with Whitaker: the War-time Diaries of the Countess of Ranfurly, 1939–1945* (Mandarin, 1995), p. 364.

17 *Hiroshima*, edited by Adrian Weale (Robinson Publishing Ltd, 1995), p. 167.

18 Daniel Farson, *The Gilded Gutter Life of Francis Bacon* (Century, 1994), p. 134.

19 Robert Hughes, *The Shock of the New: Art in the Century of Change* (BBC Books, 1980, revised 1991), p. 9.

20 Janet Dunbar, *Laura Knight* (Collins, 1975), p. 228.

21 Orpen used the term to describe the delegates to the Paris Peace Conference. Habitually dressed in frock coats they were, in his opinion, too self-important.

22 Michael Holroyd, *Augustus John* (Penguin, 1976), p. 425.

23 Ibid., p. 679.

24 This portrait, painted in 1944, is in the Tate Gallery, London.

25 Olson, *John Singer Sargent, His Portrait*, p. 116.

26 *A Free House! or the Artist as Craftsman, being the Writings of Walter Richard Sickert*, edited by Osbert Sitwell (Macmillan, 1947), p. xxvi.

27 Ibid., p. 301.

28 *Paintings by Walter Richard Sickert* (Introduction by Hugh Walpole), Savile Gallery, London (1928).

29 John Woodeson, *Mark Gertler, Biography of a Painter, 1891–1939* (Sidgwick & Jackson, 1972), p. 114.

30 *Mark Gertler: Selected Letters*, edited by Noel Carrington (Rupert Hart-Davis, 1965), p. 10.

31 John Woodeson, *Mark Gertler, Biography of a Painter, 1891–1939*, (Sidgwick & Jackson, 1972), p. 229.

32 *Mark Gertler, the Early and the Late Years* (Ben Uri Gallery, 1982).

33 Lytton Strachey, *Eminent Victorians* (Penguin, 1986 edition), p. viii (Introduction by Michael Holroyd).

34 Andrew Sanders, *The Short Oxford History of English Literature* (Clarendon Press, 1994), p. 514.

35 Keith Clements, *Henry Lamb: the Artist and his Friends* (Redcliffe Press, 1985), p. 195.

36 Diana Filby Gillespie, *The Sisters' Art: the Writings and Paintings of Virginia Woolf and Vanessa Bell* (Syracuse University Press, 1988), p. 163.

37 Jane Dunn, *A Very Close Conspiracy: Vanessa Bell and Virginia Woolf* (Pimlico, 1990), p. 148.

38 Ibid., p. 273.

39 Ibid., p. 91.

40 Painted c.1900. National Portrait Gallery, London.

41 Kenneth Pople, *Stanley Spencer* (Collins, 1991), p. 381.

42 David Sylvester, *The Brutality of Fact: Interviews with Francis Bacon* (Thames & Hudson, 1987 edition), p. 174.

43 John Hayes, *The Art of Graham Sutherland* (Phaidon, 1980), p. 32.

44 John Hayes, *Portraits by Graham Sutherland* (National Portrait Gallery, 1977), p. 5.

45 Robert Calder, *Willie, the Life of W. Somerset Maugham* (Mandarin, 1990), p. 34.

46 Roger Berthoud, *Graham Sutherland, a Biography* (Faber & Faber, 1982), p. 141.

47 Edward Sackville-West, *Graham Sutherland* (Penguin Modern Painters, 1943), p. 11.

48 *Graham Sutherland, a Biography*, p. 224.

49 Ibid., pp. 224–5.

50 *Portraits of Helena Rubinstein* (National Portrait Gallery, 1977).

51 *Portraits by Graham Sutherland* (National Portrait Gallery), p. 28.

52 Norbert Lynton, *The Story of Modern Art* (Phaidon, 1980), p. 56.

53 Oscar Wilde, *The Portrait of Dorian Gray* (Penguin, 1985 edition), ch. 1, p. 9.

54 Kenneth Clark, *Looking at Pictures* (John Murray, 1960), p. 189.

55 *The Story of Modern Art*, p. 209.

56 F. R. Leavis, *New Bearings in English Poetry* (Chatto & Windus, 1942 edition), p. 13.

57 During the Renaissance true-to-life portraits were referred to as 'counterfeits'. For a discussion of this see Jay Williams, *The World of Titian* (Time-Life, 1972 edition), p. 123.

58 Meyer Shapiro, *Van Gogh, Library of Great Painters* (Harry N. Abrams, n.d.), p. 18. (Original edition published New York, 1950; London, 1951).

59 Herbert Read, *The Philosophy of Modern Art* (Faber & Faber, 1964), p. 193. (Quoted from his discussion of Paul Nash's autobiography, *Outline*.)

Acknowledgements

I would like to thank the Director of the National Portrait Gallery, Dr Charles Saumarez Smith and the Curator of the Twentieth Century Collection at the National Portrait Gallery, Honor Clerk, for so kindly agreeing to read my manuscript and for their helpful comments. I would also like to thank the Director of Studies at the Paul Mellon Centre for Studies in British Art, Brian Allen, for his support with this book. I am grateful, too, to Les Rodger for his computing assistance when the deadlines were tight. Above all I want to thank my friends, and especially June Plaat, for their belief in me and for their constant encouragement.

The author and publisher gratefully acknowledge the following for permission to reproduce copyright material:

John Singer Sargent, *Dame Ethel Smyth* (NPG 3243), 1901; reproduced by courtesy of the National Portrait Gallery, London.

Gwen John, *Dorelia by Lamplight at Toulouse c.*1903–4; from the Collection of Mr and Mrs Paul Mellon, Upperville, Virginia; © Estate of Gwen John, 1998. All rights reserved DACS.

Mark Gertler, *The Artist's Mother*, 1911; photograph: Tate Gallery, London; reproduced by courtesy of Luke Gertler.

Henry Lamb, *Lytton Strachey*, 1914; © Tate Gallery, London, 1998.

Vanessa Bell, *Mrs St. John Hutchinson*, 1915; photograph: Tate Gallery, London; © Estate of Vanessa Bell, 1961.

Sir William Orpen, *The Artist*, 1917; reproduced by courtesy of The Imperial War Museum, London.

Augustus John, *Lady Ottoline Morrell* (NPG 6095), 1920; reproduced by courtesy of the National Portrait Gallery, London, and the artist's estate.

Sir William Nicholson, *Gertrude Jekyll* (NPG 3334), 1920; reproduced by courtesy of the National Portrait Gallery, London.

Sir John Lavery, *Hazel in Rose and Grey, c.*1920; © 1922, Guildhall Art Gallery, Corporation of London, UK/Bridgeman Art Library, London; reproduced by courtesy of the artist's estate.

Walter Sickert, *Hugh Walpole*, 1929, The Burrell Collection, Glasgow Art Gallery and Museum; © Estate of Walter Sickert, 1998. All rights reserved DACS.

Sir Stanley Spencer, *Self-Portrait with Patricia Preece*, 1936; reproduced by courtesy of the Trustees of The Fitzwilliam Museum, Cambridge; © Estate of Stanley Spencer 1998. All right reserved DACS.

Dame Laura Knight, *Ruby Loftus Screwing a Breech Ring*, 1943; reproduced by permission of The Imperial War Museum, London.

Graham Sutherland, *Sir Winston Churchill*, 1954 (destroyed).

Frank Auerbach, *Head of EOW III*, 1963–64, private collection; photograph: Marlborough Fine Art (London) Ltd.

John Bellany, *Self Portrait with Jonathan*, 1967, The Burrell Collection, Glasgow Art Gallery and Museum.

Francis Bacon, *Self Portrait*, 1973, Private Collection/Crane Kalman Gallery, The Bridgeman Art Library, London; © Estate of Francis Bacon/ARS, New York and DACS, London, 1998.

David Hockney, *Henry in Italy*, 1973; © David Hockney.

Tom Phillips, *Dame Iris Murdoch* (NPG 5921), 1984–86; reproduced by courtesy of the National Portrait Gallery, London.

Maggi Hambling, *Professor Dorothy Hodgkin* (NPG 5797), 1985; reproduced by courtesy of the National Portrait Gallery, London, and kind permission of the artist.

Lucien Freud, *Night Portrait*, 1985–6; reproduced by courtesy of the Hirshhorn Museum and Sculpture Garden, Smithsonian Institution, Washington D.C., Joseph H. Hirshhorn Purchase Fund, 1987. Photographer: Lee Stalsworth.

Index